EST CARD F

Television, Mythinformation and Social Control

AK
PRESS

"Among the worst mistakes a prisoner could make was to watch (to notice) another prisoner's mistreatment. There the SS seemed totally irrational, but only seemed so. For example, if an SS man was killing off a prisoner and other prisoners dared to look at what was going on in front of their eyes he would instantly go after them, too. But only seconds later the same SS would call the same prisoners' attention to what lay in store for anyone who dared to disobey, drawing their attention to the killing as a warning example. This was no contradiction, it was simply an impressive lesson that said: you may notice only what we wish you to notice, but you invite death if you notice things on your own volition. The issue was again the same; the prisoner was not to have a will of his own."

<div align="right">Bruno Bettleheim, The Informed Heart</div>

First Printing 1994

AK Press

22 Lutton Place P.O. Box 40682
Edinburgh, Scotland EH8 9PE San Francisco, CA 94140 0682

British Library Cataloguing in Publication Data
Test Card F:Television, Mythinformation
and Social Control
320.23
ISBN 1-873176-91-0

But first a word from our sponsor...

It is better to suck and fuck until your knees wobble, than to squander your youth on reformist politics

DON'T YOU THINK IT'S TIME TO Stop Watching T.V.?

Television is the most pervasive mass medium and the principle leisure activity in a society desperate for effective communication. The national daily average for viewing in 1989, according to the BBC, was 3 hours and 46 minutes. In other words, for people who have grown up with television, around 10 years of a person's life will be spent in front of the set. Leisure? Maybe watching television would be better described as occupation—we watch from birth to death; more hours of a person's life is spent in front of the screen than working. With the advent of a terminal for a familiar stranger's voice in nearly every Western household, we have realized a situation of dependence science fiction writers of the '50s only fantasised about.

Watching television is qualitatively different from other forms of communication in that it is the *giving* of attention detached, for the most part, from activity and specific subject matter. We tend to use television at set times in the daily routine, despite the uniformity of objects set out for attention. For the media industry (commercial and 'public service') this attention giving is a valued commodity and the audience an economic requirement. The film-maker Godard suggested that viewers should be paid for watching considering the labour time involved and the economic service rendered.

Could it be that television has no other direct purpose than that of attracting and holding our attention? It is certainly distraction and diversion that the medium excels in, filling in the time between work, sleeping and eating, wonderfully suited to the convenience (stay indoors), comfort (don't move) and indolence (don't think) of the viewer. When reality means the burden of a dull and repetitive job, then television becomes a well-earned escape. The State benefits greatly from this tension management in that, like the role of women in the nuclear family, television aligns its own schedule with the rhythms of work to ensure the worker is rested and ready to return to the grind next day.

The broadcasting bureaucracy is very proud of the 'informational' role TV plays in society. A BBC survey—for what it's worth—found that 58% of the population use television as their main source of news and that 68% of all those interviewed believed that TV news was a trustworthy medium. Certainly TV is the major distributor of information and so it is said "criticise TV and you criticise communication". What is left out is determination of the actual content of this information, the nature by which it is conveyed, and what is its effect upon us, the receivers. It will be argued that this transmission can only serve to enforce social control, that far from 'telling us what is going on', television conforms superbly to John Major's demand that we need to condemn a little more and *understand a little less*.

SEND IN THE CLOWNS

"People are dissuaded from making any criticism of architecture with the simple argument that they need a roof over their heads, just as television is accepted on the grounds that they need information and entertainment. People are made to overlook the fact that this information, this entertainment and this kind of dwelling place are not made for them, but without them and against them."

Ivan Chtcheglov

Life is hard for TV programmers; not only do they have to provide an endless supply of material, they have the added difficulty of providing a succession of new and unique products. The task is impossible, only the *appearance* of novelty can be attained (so what appears as 'news' is often opinion recycled as coverage of the coverage). The problem of raw material arises particularly in relation to the news where reporters and technical equipment have to be present for an event to be reported. There is a tension between the need to report news, which is by definition unexpected, and the need to plan for and anticipate the occurrence of such events and their location. If only life could be as predictably unpredictable as soap opera. The networks must have sighed with relief when George Bush delivered them a Gulf War right on schedule—what on earth would they have done with all the pre-prepared Gulf graphics and mediamen 'on the scene'? ITN had 75 reporters and technicians in the war zone costing the news budget an extra £120,000 a day (Times 28.1.91). They don't invest that kind of money without expecting a big return in footage, on time and on target.

Kurt Lang's study of television coverage of U.S. General MacArthur's return from command of the war in Korea is the classic account of an event *manufactured* by the media through major coverage by its own creators. The General had been invited to help Chicago celebrate ''MacArthur Day'', the highlight being a parade, the proceedings to be televised. Lang's experiment was to compare what the real-life spectators at the event experienced, to what was put out on television.

The spectators found themselves jammed in the crowd and complained that it was hard to see what was actually going on, their most common remark being along the lines of ''I bet

my wife saw it much better on television'' and ''We should have stayed home and watched it on TV''. And they were right: television gave the viewer 45 minutes coverage of MacArthur from all the best angles, interspersed with shots of waving, noisy crowds. The researchers found that the cheering crowds were responding to the aiming of the cameras rather than the celebrity (who few at the event ever even saw). As the 'participants' stood, apathetic, bored and with sore feet, the viewers were being told again and again how great was the excitement of ''actually being present'' at ''the greatest ovation this city has ever turned out''. Fifteen explicit references were made by the commentator to the ''unprecedented drama of the event''.

The researchers' conclusion was that the representation of the event was true, not to actuality (a relatively small scale and muted occasion), but ''to what was interpreted as the pattern of viewers' expectations'', that is, to what television had anticipated it should be appear to be. This is a very old but well-documented example of how television presents us with not what has happened, but what has been created, selected and defined as having happened in order to fit the established media formats.

The Gulf War demonstrated how the media can conspire with government and its military wing to create its own version of realities. Every journal, newspaper and network (and us, their consumers) were herded into the virtual environment of the U.S. Department of Defence-organised media pools for information and imaging. In a telling statement, CNN, one of the networks favoured with pool membership, bragged that it won the Gulf War by piping Pentagon-supplied information into Saddam Hussein's living room—the same disinformation, dear viewer, that we received. (According to the magazine Index on Censorship, pool journalism was ''originally sold to journalists as a method of *enhancing* access during wartime'' when reporters become reliant on the military for transport and transmission facilities. ''We went willingly, passively and stupidly along with it... and I don't blame anyone as much as I blame us'' says Stanley Cloud of Time magazine).

Much of the information we receive comes one-eyed and distorted, much of it is delivered as packaged spectacle. What purpose is it intended to serve? Whose interests are being pushed?

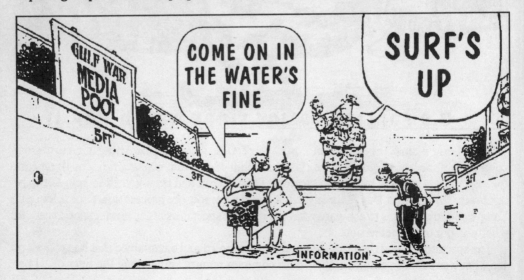

HIS MASTER'S VOICE-OVER

"We insist on a broadcast environment that reinforces our corporate message."

General Electric Communications Manager

It seems an obvious thing to point out but: the media is *very big business*. Information and communication services now account for more than half the economic activity in the U.S. Entertainment is the States' second largest export industry. Almost all of what is produced in the cultural domain is funded, produced and promoted by capitalism, it inevitably tends to work for capital's continuance. "We are", says a Granada TV senior programmer, "a company geared towards increasing revenues for shareholders every six months".

The news is as manufactured a product as an electric toothbrush and is subject to the same market forces and prevailing power system. You do not make toothbrushes under capitalism to stop people buying more of them. In the same way, media product is presented as desirable and necessary; more of it is nicer still.

In Britain, where there has been a level of government regulation of commercial broadcasting since its inception, ITV bosses are moaning that all previous monopoly restrictions are not being withdrawn fast enough. Current ownership is not exactly dispersed or poverty stricken though: Michael Green, chairman of Carlton Communications which has taken over the franchise for the London area from Thames TV (59% owned by Thorn EMI) has a personal fortune of £50 million; Carlton is worth £1 billion and has a 20% stake (soon to be a controlling 39%) in Central TV which in turn has 20% in Meridian who take over from TVS. GMTV, who got the franchise over TVa.m is owned 20% by LWT (itself 20% owned by Granada), 20% Scottish TV, 15% Guardian (who own the Observer) and 15% Walt Disney.

Globally, there are as few major players; ownership worldwide is in conglomerate hands—it would be easier to list the sectors of industry that a multi-media company such as Thorn EMI *don't* have a stake in. "In ten years time there will be only ten global corporations of communication" supposed an overly optimistic Robert Maxwell in 1984, "I would expect to be one of them" (even the best laid plans sometimes go overboard). Networks and programme-producing companies are themselves often only components of still larger corporations; for instance General Electric-RCA-NBC is the merger of one of the Big Three U.S TV networks with a major U.S. Defence contractor with aircraft, weapons electronics and nuclear systems sales exceeding $40 billion.

In 1992 Time Warner, one fifth owner of Turner Broadcasting System/CNN and the largest media conglomerate in the world, had sales of $14 billion; (Murdoch's News Corporation took second place with $12 billion). Members of Time Warner's Board of Directors have directorships on the boards of (amongst others): Mobil Oil, AT+T, American Express, IBM, Xerox, General Dynamics and most of the major international banks. Hardly the environment for balanced communication. As part of a consortium of interests, Time Warner unsuccessfully bid for an ITV 'Channel 3' regional franchise two years ago. The Independent Television Commission (formerly the IBA) rejected its bid to run the projected Channel 5 (in partnership with Thames TV) earlier this year. It will no doubt get its foothold in 1994 when foreign companies will be able to take over ITV franchise-holders by buying controlling shares on the open stock-market. Such moves are inevitable: "We have an obligation to our shareholders to maximise our profits globally" says Tom McGrath, Executive Vice-President of Time Warner.

·

If they don't already own the company, multinationals exert influence on commercial broadcasters due to their position as an important source of revenue in the form of advertising. The advertisers' demands for predictable audiences is a major determinant of programming—in some ways it's the advertiser who is the consumer, we are the product and seen from this angle, programmes are merely there for maintanence of attention in the breaks between the ads. The networks don't bow to consumer pressure for more diversified programming, rather we are experiencing increasing attempts at homogenisation of audiences for corporate consumption. If you think our diet is rough now, just wait 'til you see the TV dinners U.S. media moguls are cooking up for us: ''Your country could become a backend market for companies that produce bland, generic, all-purpose, trans-cultural programming'' warned ABC's Howard Stringer in 1990. The Californication of all cultures.

Dissenting voices have not been able to make themselves heard within Britain's commercial/ quasi-public service broadcasting system. Nescafé have not shown willing to advertise between programmes advocating the liquidation of the Gold Blend yuppies. In North America, there is a group called the Media Foundation, better known by their magazine ''Adbusters'', who make environment-related advocacy ads for Canadian and U.S. television. They buy airtime for their 'infomercials' about smoking, logging and so on. They have been refused access by various networks (all NBC, ABC and CBS affiliates in Boston, for example) on the grounds that their ads ''might upset our major sponsors''—that is, the multinationals.

It is no different in the publicly-owned sector; the BBC has to compete with ITV for audiences in order to sustain its claim to the compulsory licence fee (worth £1.5 billion annually) and to avoid a ratings loss on programmes. It's exactly the same criteria of 'cost-effective' production as in any private company. Resource allocation and overall programme policy are influenced by the BBC's involvement in markets where the terms are set by the conglomerates. The latter determine the general level of production costs, through the sale of equipment, raw materials, programmes and by fixing the market price for creative labour and technical expertise. This reality has now been formalised as 'Producer Choice' where

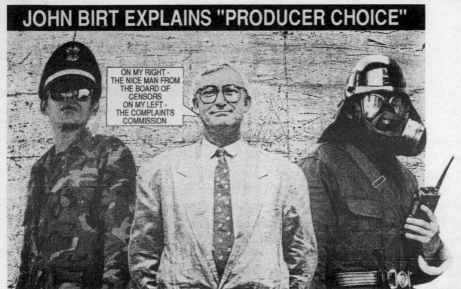

JOHN BIRT EXPLAINS "PRODUCER CHOICE"

ON MY RIGHT - THE NICE MAN FROM THE BOARD OF CENSORS
ON MY LEFT - THE COMPLAINTS COMMISSION

BBC in-house facilities are being run down as programme-makers contract out for the cheapest services in the same way as the NHS has been privatised. It will ultimately lead to the BBC becoming like Channel 4, a publisher to commercial programme makers—it was this transformation that the new Director General John Birt was employed to oversee. The BBC cannot cut production costs significantly as it cannot let its total share of a finite audience slip below 50% for any length of time. It has to offer products with the same formats and content as the commercial sector (and produce the same 'trans-cultural' programmes for sales overseas). Huw Wheldon, former Managing Director of BBC TV commented that, "It is always difficult for people to accept the brutal proposition that competition means putting Like against Like, but the fact remains that it is so".

> In the years immediately after the war, drama slots were dominated by anthologies of single plays, many of which dealt with working-class life. While these were popular with audiences and regularly attracted high ratings, they increasingly worried advertisers who saw plays with lower-class settings as damaging to the images of mobility and affluence they wanted to build up around their products. Accordingly, in 1955 they begin to switch their sponsorship to the action-adventure series that were beginning to emerge from the old Hollywood studios. The business advantages were obvious. 'Drama moved outdoors into active, glamorous settings. Handsome heroes and heroines set the tone — and some proved willing to do commercials, and even appear at sales meetings and become company spokesmen' The series also had distinct advantages for the production companies. The fact that they contained the minimum of dialogue and the maximum of action made them ideal export material. They were intelligible anywhere that audiences were familiar with Hollywood westerns and thrillers.

The pressure to maximise audiences and revenues results in the avoidance of anything that might be contentious. Production and commission is based instead on the familiar formats of what has previously successfully kept us watching. Getting the bodies sat in front of the box for as long as possible is what counts; *quality* of attention is of little importance.

It would be surprising under these conditions to find television adopting a consistently critical perspective on society, or giving interpretations at odds with the dominant capitalist value system. Television is controlled, not by its viewers, but by a professional minority who make the programmes and commercials to make money for an even smaller minority and to shape the world to guarantee both minoritys' continued position within it. Those most likely to dissent from this set-up are precisely those *without* the resources to be heard.

Even so, it is patently not the case, in Britain anyway, that we receive a continual barrage of undiluted corporate and State directives. It is relatively easy to read between the lines of explicit propaganda for particular capitalist enterprises or the government of the day. The messages of this medium are many and multi-layered. It is in rather more subtle methods that we find television's power to shape social reality and enforce social control.

THE DEMOCRATIC FANTASY FACTORY

> "Broadcasters are operating within a system of parliamentary democracy and must share its assumptions. The State demands our loyalty because, through the armed forces and the police, it alone can defend us from invasion or anarchy."
>
> Annan Committee Report on the Future of Broadcasting 1977

Television is impartial! This has been an official requirement placed on the broadcasting companies by the charters which govern them and written into all the Broadcasting Acts since John Reith became the first Director General of the BBC. According to both act and charter, television is a public resource to be used in the public interest (though we have just begun to have open programme sponsorship as in the U.S.)

The emergence of television as principal source of news has resulted in a shift away from consumption of a medium with a known tradition of partisanship to one which is required to be 'politically balanced'. We expect the newspapers to relay certain party lines and so buy and interpret them on the understanding that they are opinionated. A survey two years ago found that the regular readers of the Sun that trusted it "not at all" outnumbered all those who trusted it either "a great deal" or "a fair amount".

It is this label of impartiality that gives broadcasting its prestige and respectability, for without it informational programmes such as the news could not be distinguished from entertainment, advertisement or party political broadcast. Therein its power lies—television secures credibility precisely because its independence from the direct play of political or economic interests is not *completely* fictitious. Within a limited sphere, that of parliamentary politics, it generally *is* impartial, observating statutory requirements that it should take account of "not just the whole range of views on an issue, but also of the weights of opinion which holds these views" (Annan), as demonstrated by returns at the ballot box. Those who did not vote, spoiled their vote, or never even registered to vote, despite being around half the population, do not come within these terms of reference. The short term effects of television on voting preferences during election-time appears limited; its power lies in its long-term function of maintaining the illusory unity of 'democratic' politics. This is more important for the state than any temporarily-exposed revelation, fraud or scandal which soon get swept away as the tide throws up the next exposé. How this works in the interest of the institutions of capitalist democracy can be found as far back as the General Strike in 1926 in John Reith's defence of the BBC's strike-breaking role:

> "Since the BBC was a national institution and since the government in this crisis was acting for the people, the BBC was for the government in this crisis too."

Both BBC and ITV have the right to waive impartiality in their coverage of those events and issues which are considered (by who—John Birt?) to undermine the 'national interest'. Currently this impartial *partiality* appears most openly whenever Northern Ireland is mentioned:

> "The BBC told us that they could not be impartial about people dedicated to using violent methods to break up the unity of the state. The views of illegal organisations like the IRA should be broadcast only when it is of value to the people that they should be heard and not when it is in the IRA's interest to be heard"
>
> Annan Report

You don't need to be Republican or violent to end up on the dark side. Tasteless or foulmouthed will do:

> "That nothing be included in the programmes which offend against good taste or decency or incite to crime or lead to disorder or be offensive to public feeling or which contains any offensive reference to any living person."
>
> Television Act 3.1(a) 1954

That should cover most everything you might be thinking about the society we live in. In our great British democracy it is assumed that there exist no fundamental conflicts, that we all enjoy equality before the law and equal access to decision-making by means of elections. According to this model, television is justified in putting those who refuse to be derailed onto the false and futile paths of lobbying, petitioning and voting, into the pigeonholes labelled: deviant, fanatic, extremist and even the unnatural. Tolerance is exercised only within the narrow sphere of what a minority considers to be tolerable. It is the means by which the powerful interests in an unequal society claim everybody, for whoever defines the ''public interest'' has made themselves its sole judge and representative.

Television systematically underwrites a set of institutional procedures—the rules of the game—that operate to the benefit and dominance of a minority at the expense of the rest of us. The staple diet of news is conflict, violence and disruption. For all these 'negative' events to be newsworthy, the prior assumption of a 'right' and a 'wrong' violence has been put up, along with the proposition of consensual support for those who heroically defend civilisation against the deviant and extremist threat. The interminable debate on over-exposure of violence is a false one: television is a principal weapon for socialising us into the aggressive, dehumanised roles that makes the barbarism of capitalism work so well . We have only to consider the 'respectable' violence of state-managed wars to appreciate this.

Owners, managers and politicians giving 'legitimate' opinions will never be asked to justify why, for example, the wheels of industry *should* continue to turn for the bosses' profit,

whereas industrial disputes are framed around breakdown of normality and a disruptive element's effects on 'our' balance of payments and 'our' national economic performance. Any content analysis publication by the Glasgow University Media Group and Campaign For Press And Broadcasting Freedom provides countless examples of the framing of interpretation through choice of **language**—we hear of "hopes of a return to work" (*whose* hopes?), "the dispute *by* strikers..." and "violence on the picket-lines" (rather than on the *police*-lines) and we are assaulted by manipulation of **image** (such as the swapping of the order of filmed footage of the 'Battle of Orgreave' during the Miners strike).

All news coverage is encoded to enforce the myth that we live in a society where the bond that unites worker and boss is an national economic interest, stronger than the divide between labour and capital. Certainly, without a whole range of unstated premises (things that are taken for granted) every television statement would be literally unintelligible. But it is these presuppositions which are rarely made explicit (unconscious often to both transmitter and receiver) which serve to make capitalism appear fixed, inevitable and natural. They are disguised as already known and established facts, 'common sense'; they are not open to reason, argument or logic. You cannot learn from the telly of construction—*why* things may come about and what ends they may serve. You can only witness the existing state of things. We get merely who, how, when and where, and that much only on occasion. The news are actually *olds* as they reproduce the world of 'how things are' and, by implication, how things were and will always be. The media operates to effect a closure on knowledge by explaining events only in the terms of what we are *taught to know*.

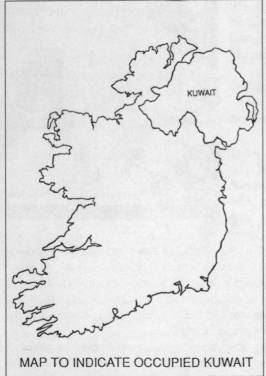

MAP TO INDICATE OCCUPIED KUWAIT

The assumption of a consensus leads to its reproduction, and official bias has now been naturalised through systematic exclusion of any alternative perspective. Eamon McCann suggested over 20 years ago that on Northern Ireland: "The great majority of the British people are by now incapable of forming a judgement, so one-sided has the reporting been."

In order to perform its anti-social function of democratic socialisation television must appear relatively autonomous in its daily operations—it cannot be seen to take directives from the powerful or willfully bending accounts in any one interest group's favour. Though it does occur, blatant government intervention is avoided; instead a system of self-censorship and 'reference upwards' operates within the framework of 'what all good Englishmen and women are agreed upon'. Again Northern Ireland disrupts the transmission formula: Sinn Fein has qualified as a legitimate political party through the electoral process, with as

much credibility as the Labour and Conservative parties (not much). Neither 'normalisation' nor 'criminalisation' has been able to hide the existence of a huge section of the population in open revolt against the rules of the game, electing MP's as a tactic of dissent. Media silence is now being experimented with, decreed by the Home Secretary under broadcasting legislation that gives him absolute power to prohibit any programme without further parliamentary approval. We might wonder though why this was thought necessary: in the year before the ban the BBC screened 17 basically hostile interviews with Sinn Fein; embers of the Tory Party got 121 mostly grovelling, lick-spittle crocodile tear interviews, 50 of them with Northern Ireland Minister Tom King alone. As David Nichols, editor of ITN remarked: ''British public opinion has never been more resolute

than it is now... and that owes a lot to the full and frank[!] reporting that we've been able to conduct on Northern Ireland over 19 years''. The extensive self-censorship which existed before introduction of the ban on direct speech had much the same effect as the terms of the ruling itself.

Sinn Fein is the exception; normally broadcasting promotes the flow of fatuous declaration and counter-accusation between political parties from the debating chamber. It adheres to non-partisan, even anti-partisan standards of fairness and neutrality in raising the players high and dishing out the cynicism. This is maybe at the expense of a readiness to take sides. Television contributes to a widespread and chronic distrust of political life; this is manifest less in a refusal of interest in hierarchy's wheeling and dealing (which, like the growing refusal of work and tax evasion is to be encouraged) and more in a retreat from activity and into passivity, recoiling from the way in which crisis and stress are thrown at us in a complexity of events beyond our experience. Since we have little specialized knowledge of the political circus, coverage of 'major political events' does not clear confusion, it multiplies it and *lowers* the possibility of knowledge being fused with activity. A man in a waffle house tells the Washington Times about the Gulf War: ''Everyone's tired of the media's talking... not getting anything done. What's the point?'' (Index on Censorship 4+5/1991). The result for many is an *im*mobilisation, a denial of any sides and the unlikelihood of thinking in terms of a self-active solidarity between equals. Social and self knowledge is mutated into 'politics', a hobby that it is possible to be interested in, or not. Scepticism towards anything 'political' contributes to an unwillingness to consider the point of organising to *destroy* hierarchical relations. This comes about not because television fails to 'lead' in opinion manufacture but because daily it imprints on its viewers a debilitating feeling of utter powerlessness and commitment to just one activity: watching more television.

When people are asked why they watch current affairs programmes, they tend to give 'surveillance' reasons more than any other. Often when open propaganda is conveyed *we are* on our guard, but we tend to be less so when we believe we are simply receiving 'information'. Though hype and sensationalism is critically identified, the news is widely taken to be an impartial record of the events of the day, the unprocessed reality of a world narrating itself. The whole idea of news, though it is only story-telling, is that it is beyond interpretation, that it is but objective information. All who work in television are complicit in this illusion, the illusion that is a neutral carrier through which reality is revealed without mediation. News representation is the constant denial of its own process, a conjuring trick of turning ideology into fact. The myth of information is that there is a collection of facts and events floating around that diligent newspeople just have to gather for us. Facts are made in *fact*ories, using labour to make things mean, fabricated to describe what its *producers* wish to see around them. As Alan Fountain, Channel 4 Commissioning Editor for the Independent Sector let slip: "Every report, every picture, every word put out necessarily favours one side or the other." This is the hidden agenda—the myth of information works better here than it did in the former Communist States because many believe that the media is free from control. At least under communism citizens knew they had to discount for probable lies.

Selective frameworks are imposed to exclude alternative interpretations. It is predetermined which issues are presented for attention. While the media realise that it cannot tell people exactly *what* to think, they reckon they can certainly tell us what to *think about*. Gulf War coverage carved the impression that what was occurring had greater significance than our normal day's events. Not only significant—the message was that war is the most exciting human activity there is. Meanwhile almost all of us still went to work at dull jobs or stood in the dole queue, shopped at the supermarket and watched TV. No phony issue of earth-shaking proportions changes that reality.

Television appears to provide a coherent picture of what exists, what is important, how things are related and what is right at *any one moment* in time (within the dazzling array of a typical evening's scheduled *in*coherence). It projects a view of the world that is consistent only within its narrow confines—it *seems* to make sense—always without the 'but maybes' and synthesis of contradictions that are so useful in personal communication. New news has novelty only within the familiar pattern of how it already always is presented. Through continual repetition of stereotyped plots and characterisations of villains and victims (in the

MEDIA MANAGEMENT

I am writing to put straight a story that the media jumped upon last summer. It was at the Otterbourne Festival where someone set fire to a disused Council Incinerator plant which they reported caused £1 million worth of damage.

The only reason why there were people near the out-house was because police refused to allow them on site and funnelled them onto a field next to the building.

After the fire started, the fire brigade arrived but the police refused to allow them on site saying it wasn't safe for them. But they did allow the media in. It was half an hour before the police allowed the fire brigade on to the site; half an hour for the fire to burn and half an hour for the media to photograph it. When asked about the delay they said that they had needed time to gather together a police escort for the firemen... None of this was reported in the press. Yours,

Mike (traveller)

Letter to squatters magazine Squall
2 St. Pauls Rd, London N1

news as much as in the soaps) they project partial images of reality and organise selective mass sympathies. The result is containment within a TV-centred value system: everything is true and nothing is permitted outside its confines.

Television does not influence us simply to make certain decisions; it is not *openly* ideological. The purpose is not to choose this opinion or that, but to define the narrow terrain of

"Meaningless statistics were up one-point-five per cent this month over last month"

possibilities and the limited horizons of acceptable thought and innocuous action. Maybe the intention is for us to make no decisions at all, simply to ensure that we still have the illusion of choice while being absolutely certain that it doesn't matter as it is always from a list of safe alternatives. Even debating the imminent collapse of capitalism is no threat so long as television is the forum of discussion where "Black Monday", Black Friday, any day of the week Stock Exchange collapses can be redefined as an electronic problem set off by irresponsible computer trading; where accidents happen but do not reflect back upon the confidence trick of economic exploitation itself; where television's economic reason-to-be as mechanism for production of commodity-linked spectacle remains intact. Broadcasting 'balance' suggests a 'left' opinion and a 'right' opinion with *the truth* lying somewhere in the middle—what the TV thinks (even at the expense of the political masters themselves—television

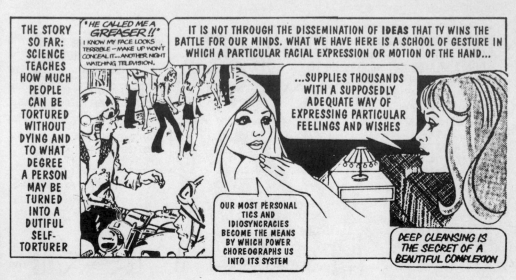

THE STORY SO FAR: SCIENCE TEACHES HOW MUCH PEOPLE CAN BE TORTURED WITHOUT DYING AND TO WHAT DEGREE A PERSON MAY BE TURNED INTO A DUTIFUL SELF-TORTURER

"HE CALLED ME A GREASER!!" I KNOW MY FACE LOOKS TERRIBLE—MAKE UP WON'T CONCEAL IT...ANOTHER NIGHT WATCHING TELEVISION.

IT IS NOT THROUGH THE DISSEMINATION OF IDEAS THAT TV WINS THE BATTLE FOR OUR MINDS. WHAT WE HAVE HERE IS A SCHOOL OF GESTURE IN WHICH A PARTICULAR FACIAL EXPRESSION OR MOTION OF THE HAND...

...SUPPLIES THOUSANDS WITH A SUPPOSEDLY ADEQUATE WAY OF EXPRESSING PARTICULAR FEELINGS AND WISHES

OUR MOST PERSONAL TICS AND IDIOSYNCRACIES BECOME THE MEANS BY WHICH POWER CHOREOGRAPHS US INTO ITS SYSTEM

DEEP CLEANSING IS THE SECRET OF A BEAUTIFUL COMPLEXION

can be trusted is the inference simply because, as it is pleased to reveal, politicians *can't* be). It proposes that everything will come up rosy so long as there are enough people in the studio gabbing on about it. In this way it makes itself vital as sole arena of contestation.

The ideological 'bent' of what is transmitted may be important but it is the maintenance of viewer attention—Being There, not somewhere else or doing something else—that is *all*-important. The shows, soaps and scandals are simply the minimum required to ensure that reception. Programmers don't care what's on so long as the set takes centre stage in social life:

> "We watch and react in different ways to a multitude of things, and the extent of those things, its "everything" goes beyond any possibility of its being read off according to some single ideological transmitter... Television is always at the same time bound up in the work of ideology, the saturation of signs and messages and the erasure of the struggle for meaning into fragmentation as the world in action, the perpetual flow of a constant present without any hope beyond its repetition... the holding definition of the existing and the possible versus the conflict of groups and classes, the forging of political meaning."
>
> Stephen Heath, Representing Television

Conformity is achieved in the act of sitting down and turning on; whether it's Terry and June or John Pilger you tune into is immaterial. TV capitalism—the show biz spectacular commodity system—is a way of life. It follows as 'logically' as counter arguments which seek to change the rules of the game necessarily 'stray from the point' and appear 'trivial' to the real business of taking care of business and keeping the pecuniary mangle turning.

Television shapes perception so that we accept our role in the existing order, either because we see no alternative to life beyond this scorched earth, or because we have been accustomed to perceive it as natural, unchangeable, even beneficial. It is in winning a universal validity for accounts of the world which are partial and particular that we come full-circle: through impartiality is produced bias; through dissemination of manipulated social knowledge, enforcement of social control.

THE RUTTING DOGS OF CAPITALISM

"They want to be able to say that they did not commandeer us, but they know they can trust us not to be really impartial."

John Reith

Television is no meeting place for the free flow of ideas and imagination. Broadcasting is the manufacture and distribution of symbolic goods within a controlled programme schedule. Its contents and formats reflect reality as seen from within the industrial structure of the media itself. Especially for this industry, time is always money, which makes certain choices for information and image gathering easy, others more difficult. Costs must be kept down and the scarcest resource is time of manufacture. Programmes are made by people with little knowledge, even less experience and no time to acquire either. In-depth research comes low on the list of priorities, recourse to quickie convincing talking-head explanations from 'specialists' is more the norm.

Television's claim to be objective necessitates cultivation of expert phrase-mongers insofar as what is really mere opinion makes more credible TV if some official-sounding spokesperson can be found to say it. A 'hierarchy of credibility' operates in that people in high status positions will have their views accepted because they are understood to have access to some *over*view that the majority lacks. In a society based on specialisation, where the totality seems an impossibility to grasp, an information structure directed towards *mass* consumption has a built-in elitist focus on *those who know* and are simply *known for being well known*. Government, big firms and other large organisations (Oxfam, Friends of the Earth, Class War) will have employed someone whose specific job it is to liase with the media. Groups with political or economic power do have privileged access to the media because they have the resources to process information and to offer the media their views in a usable and attractive form, tailor-made to fit TV requirements. The lifestyles of the rich and famous give them the time to be available for consultation or interview (while the reward of positive coverage nurtures future compliant and ideologically reliable celebrities, further underlining the approved paths to positions of 'success'). The fact that these people accrue credibility simply for being who they are is demonstrated in one of the government's declarations in support of

17

the ban on Sinn Fein: '"Those who apologise for terrorism gain a spurious respectability when treated in broadcasts as though they were constitutional politicians".

Who are these opinion-mongers anyway? Dr. Mouthpiece, member of the Prime Minister's personal advisory committee (on taxpayers' money) and hardline rightwinger goes on telly as "Professor at La-dee-da University who specialises in Terrorism". Don't believe it works like that? To find out you'll have to do some investigative journalism (the groomers of these talking heads won't be doing it for you). General Electric funds conservative think tanks such as the American Enterprise Institute whose members then appear as 'independent specialists' on networks owned, or shows sponsored by the same corporation. Look out on Brit TV, especially if unemployment gets discussed, for a certain Michael Moynagh who, in whatever guise he'll be presented, is also a former adviser to the Confederation of British Industry and born-again Workfare-promoter for the Evangelical Alliance.

'Radical' journalists complain that the hierarchy of credibility is an *external* constraint put on the media:

> "Most journalists in Northern Ireland are almost completely dependent on the army's information service simply because there is no other source for news of day-to-day violence"

declared the Guardian's Simon Hoggart. But this is no excuse for consistent misreporting. We could ask straightaway why they never use the equally 'impartial' Sinn Fein Press office. Media people know that their business is not counter-information, journalists who want to stay in their jobs keep in with the Army and their editors' and managers' expectations. And besides, since the Army's public relations men have the backing of the state they don't have to worry too much whether their statements are true or not. Professionals understand professionals. Particularly telling is Hoggart's less well-quoted reflection that:

> "Most only check when there is time or the incident looks like becoming controversial"

that is, when there's the likelihood they're not gonna get away with it. The line of least resistance and audience maximisation is in following 'conventional wisdom'. Contrary to Hollywood portrayal of reporters as men of action, as corruption diggers with live coverage

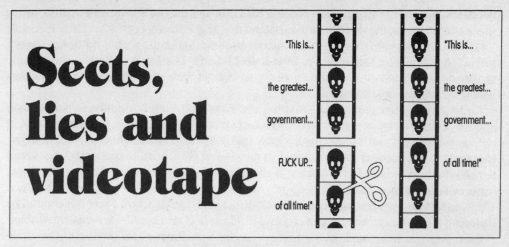

Sects, lies and videotape

"This is... the greatest... government... FUCK UP... of all time!"

"This is... the greatest... government... of all time!"

deadlines to meet in the killing fields of political life, most of them want a quiet but well-paid niche in the system. The myth of media independence is a convenience that hides detachment *only from their audience*. Programmes are produced to be accepted by decision-makers on the next rung up the ladder.

The media do such a good job of censoring themselves, there is little need for draconian guidelines. By the work they do not do, they uphold official definitions of reality; by the work they do, they disseminate it.

> "Arab-American Television in Los Angeles which broadcast videotape of the aftermath of air-raids, claimed that other networks had access to the same footage and chose not to show it."
>
> Index on Censorship 4+5/1991

Challenges to official versions of events might result in lost access (such as exclusion from membership of the next media war pool), government complaints to editors and owners (who frequent the same clubs and social circles as ministers) or preferential leaks to competitors on following 'headline' stories. Quiet words in ears and throwing up barriers to access makes for better manipulation than official censorship—it can kill a journalist's career just as effectively.

> "So pervasive is passivity that when a reporter actually looks for news on his or her own it is given a special name, 'investigative journalism', to distinguish it from routine, passive 'source journalism'."
>
> Walter Karp, All The Congressmen's Men

The vast majority of so-called 'leaks' are informal channeling of what someone wants to be known; they are gifts from the powerful for previous media services rendered. It is the most cringing journalists who are given the best access and become the most successful. The smartest reporters understand the machinations of the political system and the behaviour expected of them in the corridors of power.

In its defence the media will cite its identification of 'disturbing new problems', for example, the Satanic abuse exposés. The first programme on this subject was the Cook Report's "The Devil's Work". The format of this series was no-holds-barred 'telling you how it is' through—we were assured—'in-depth research' and using the now infamous tactic of

doorstepping (giving unsuspecting people a hard time in front of a TV camera with the police in attendance in case the victim tries, understandably, to get them out of his/her face). Hot stuff: ''The Cook Report is ITV's top-rated current affairs programme with 9 million viewers'' slobbered that quality shit-sheet the Guardian (23.5.91). The Devil's Work was originally screened in July 1989 to 12 million viewers, its images were much talked and its contents widely considered objective truth.

Great investigative journalism? Nothing of the sort. Looking behind the sensationalism and the mock outrage we find: Audrey Harper, who appeared in the programme giving ''evidence'' of her past satanic involvement and witness to ritual child sacrifice also just happened to be a lecturer for and executive member of the Christian fundamentalist group Reachout (she was later put in charge of the telephone helplines after the report and was featured as an ''expert'' in a follow-up programme). One of the series' paid researchers was Maureen Davies, who just happened to be ex-director of... guess who?... yep, Reachout. The Reverend Kevin Logan appeared exorcising children (a clear case of *Christian* ritual abuse if there ever was one); well, he's a member, along with Harper and Davies, of the group Evangelical Alliance. None of the events insinuated as having occurred had any basis in fact and no proof was offered. The programme's anchorman and head witch hunter is the same Roger Cook who went on TV and accused Arthur Scargill of paying off his mortgage with NUM 'slush fund' money (despite Scargill not having a mortgage at all). After a determined campaign to redress the balance, The Devil's Work has been quietly found fraudulent by the Complaints Commission (but those attacked in the programme were refused space to make and transmit their own views). Cookie's place as prime time populist bigot has since been taken by the equally cheesy ''Dispatches'' on Channel 4. Their aptly-named ''Beyond Belief'' claimed to bring us ''new evidence of satanism and ritual abuse of children in Britain—ritual abuse *is* being practiced'' (according to the Oracle programme pre-promotion). This show—it cannot be called journalism—revolved around a ten year old Psychic TV performance art video, which showed ''ritual abortion and physical torture'' according to 'reporter' Andrew Boyd (only co-incidentally editor of the rabid ''God's Word NOW'' newspaper).

Most disturbing about this scare-mongering and televangelist persecution dressed up as documentary is its attitude of righteousness in the complete absence of any evidence, *ever* (this very absence, they claim, is evidence of the cunning with which Satanists cover their tracks!).

Anti-pagan propaganda has gained currency, simply through its presentation. Dispatches' commissioner David Lloyd puts on the programme then goes on to claim in the Independent On Sunday (1.3.92): ''Surely enough disturbing evidence has come to light for us all to take it seriously''. Its existence is given not on proof (there has never been any) but on the production of 'specialists', such as evangelist Pamela Klein (imported from the U.S, one of the first to tell us that this new horror was rife there—something we had no way to verify—and, by their expert say-so, occurring in this country). One of our own home-grown soulsuckers, Diana Core (founder of the Reachout charity front Childwatch) then uses the credibility of television appearance and news currency to go on German TV (26.3.92) to insist that pagans ''boil the baby's body... they use the fat for highly prized ceremonial candles. Some high priests wear necklaces of babies' fingers''. This then gets the front page of West Germany's Bild Zeitung. Little does it matter that these eminent social workers and 'researchers' are Fundamentalists with a censorship axe to grind against anyone who does not follow their own cult mantra of Work, Family, Obey and do it in the missionary position.

Would the real abusers —

In the American report of 14 January 1991 (MUTILATED DOG CARCASSES FOUND) the reader is 'sold' the idea of Satanic Involvement in the choice of text. Thirteen carcasses were found (a mystic number). The article remarked that the Dogs had their hearts, heads, bowels and paws missing. It went into great detail to tell us that 12 of the carcasses had been skinned and that they were all found in woods laid out in a specific pattern. The investigating police officer, who had at that point not begun his enquiries, was reported as saying, "In 16 years as a police officer I've come across some pretty STRANGE things but this rates as one of the STRANGEST. There is a DERANGED person out there and their next move may be TO DO SOMETHING TO A HUMAN BEING". But the case of the Dismembered Dogs didn't remain a mystery for long. A day later the Richmond News Leader solved the riddle. The Dog Carcasses were laboratory coyotes, bred for experiments " which had been dissected by biology students on a nearby campus. It was all perfectly legal and on the up and up".

— please stand up

As the Sub-Culture Alternatives Freedom Foundation* boldly point out:

"There is no such thing as Satanic Ritual Abuse and while we waste our time addressing an artificial debate the real abusers are getting away with it"

for example, the morally righteous, sexually repressed and repressive British clergy:

"There is at least one proven case of abuse of children by Church Ministers EVERY WEEK"

and, we might add, in Social Services children's 'homes' (and perhaps integral to the structure of the nuclear family itself).**

The media, some say, are just playing games, 'for entertainment purposes only'. But what they're playing with is people's lives. Beat us *all,* like Rodney King, with one big extending truncheon? Oh no—they at least have learnt from previous Dark Ages of history and will start by demonizing the pagans, the travellers, squatters and other non-conformists, to work up scapegoats that make us all paranoid and suspicious of each other and increase the social distances between us. The media's cynical 'strategic' thinking knows no bounds: they institute a pogrom mentality then throw up their hands in disbelief at the logical outcome: the election of a British National Party councillor in Millwall, London.

It does not take a conspiracy theory to account for the convergence of interest between the media, Social Services and Christian Fundamentalists is not so surprising: they are all professions specialising in the management of oppressions; all three social groups occupy similar class positions in society and are all shut off from outside reality (as their relation to others is always from a standpoint of interest in them as objects for administration); members of all three are convinced that 'society' could not continue without their continual benevolent intervention as moral guardians.

* SAFF can be contacted at 6/8 Burley Lodge Road, Leeds. 0532 451309

** Only patriarchy has gained in the 'revelations' of satanic abuse and the very real occurrence of **social worker abuse** (prompting, insinuating and interrogative 'counselling') at Rochdale and Orkney. There has now been a resurgence of belief in 'false memory syndrome'—the Freudian notion that accounts of parental abuse are but childhood fantasies.

While the media may be dependent on the economic and political bureaucracies for their raw material, the latter are at the same time dependent on television via its capacity to deliver large audiences. This may be seen to provide the media with some sort of independent power base, a possible countervailing force against one dominant ideology; but no—state, capital and media remain locked, like rutting dogs, into the same bankrupt power structure and reproduce the central and 'obvious' perspectives of hierarchy and commodity fetishism. Television sustains and succours this beast, a benign parasite on a malignant body politic, a fourth estate built by the same racketerring estate agents. State, Church, business and media have closed ranks, merged in common defence of their entrenched power.

Television is fabricated by skilled technicians hired by bureaucrats. They are salesmen of knowledge whose livelihood is earnt processing and hawking images of life for their corporate employers. Through sleight of hand journalists have mostly managed to avoid the hatred increasingly and deservedly shown towards their fellow mercenaries in the police and the military.

Media organisations possess the same attributes which characterise other large-scale industrial structures, notably in that production is for quantity, speed and profitability, demanding a high division of labour. Power is wielded through an internal pyramid of fear and loathing. Clearly specified and accepted institutional goals—the 'editorial line'—are maintained via the informal channels of provision, or withholding, of reward and promotion. All but the lowest status media jobs are mono-

Time for your religious vomit, dear

polised by the college graduate middle class, unsurprisingly the same social strata as those in management positions in other economic enterprises and the State. Media professionals can be trusted to interpret the world in the same way as the holders of power with whom they share the same values.

"I reflect sometimes on 'politics'. The whole horrid technique should be abolished. Government of a country is a matter of policy and proper administration, in other words efficiency."

John Reith 11.10.32

The voice we hear is that of the self-serving middle class which claims to stand above sectional interest and to speak on behalf of us all in the guise of 'public interest'. A technocratic perspective of politics is the ideology of the professional communicators which legitimises the power and prestige of their position in class society. The one thing this class always is is 'realistic': "Let's face reality" they tell us; that is, let's look at it from the viewpoint of administrative convenience and business priority. This perspective proclaims to be:

socially responsible' (loyalty to the system as it stands which leads logically to a 'right' to decide what is good for us, with all the superior attitudes that entails);

'giving the people what they want' (as far as market research has determined, under conditions of pre-existing influence) and

'professional' (the same old soldiers' song to a tune that can be whistled by any concentration camp guard with an ear for the aesthetic and an eye on the gas pressure).

Go on—tell me that's sensationalism. Then tell me former BBC Director General Hugh Greene earned his journalist's stripes as Head of Propaganda for Malaysian government radio during the period of Chinese squatter Communist insurgency where mass internment of the population in 'strategic hamlets' (a very British form of imperialist warfare) predated the same methods employed by the U.S. in Vietnam and Pol Pot in Cambodia. Wherever a journalist treads, state violence is not far behind.

the

FEAR

These are your Childrun that come at you with **knives**

WANTED
A DIFFERENT WORLD
TO LIVE IN

REALLY

BOX 11

Wanted, Knives for children box 668

Wanted, Map of the forebrain
 box 8
Wanted, Fanzine editor seeks
 creativity for intellectual
 relationship box 69
Wanted, Truth, love, the
 meaning of life box 7
Wanted, Typewriters for
 children who lost their
 knives box 23

DON'T ALLOW THE MEDIA

TO SET YOUR AGENDA

YOU HAVE TO DECIDE

✝

WHAT'S WRONG & RIGHT

DECISIONS BASED ON FEAR

ARE NOT REAL DECISIONS

THINK FOR YOURSELF
THINK FOR YOURSELF
THINK FOR YOURSELF
THINK FOR YOURSELF
THINK FOR YOURSELF

HAVING A FEAST IN THE MIDDLE EAST

"The crisis in Islam in the modern world does not make 'good' TV; the delivery of a video bomb does. Even if the media spent hours analyzing Mid-East history and culture the likely result would be boredom. Because Mid-East history and culture are boring? Anything but. Because boredom is what the media delivers best. No matter what brand of information you choose to consume, you will never be a participant."

<div align="right">Anti-Media (U.S.)</div>

Television technology is able to carry on some types of communication but not others—it is at its most effective when transmitting simplified linear messages. It's especially good for advertising, (it's new, buy it; or: he's a hero, trust him and buy his lifestyle through our product) but not for much else. Believe it or not, all of life's experiences cannot be transmitted to us electronically. What it means to be a human being is only rarely glimpsed. Instead, how wonderful it must be to become fabulously rich and powerful is constantly shoved down our throats.

Programme content is always subordinate to presentation. As the Director General of the BBC at that time told the Annan Committee, ''It's no good if you put the explanation after the audience has switched off'', while ITN suggested that ''people would be bored to death'' by anything other than the usual technicolour sensationalism. The limitations of the medium demand that the images and issues presented appear dramatic, different and above all *entertaining* because watching telly is fundamentally motiveless activity. It is only the technical hype of fast editing, dissolves and stop-start image collage that keeps us from throwing it out the window. Presentation of otherworld exotica and a larger than life reality struggles constantly to break out of television's self-perpetuating spiral of indifference to mere difference. Television is a homogenising home blender of everything—*and* the kitchen sink—culture, baby, bathwater and then some. Much of the product is self-referentiality to other content and events that have only existed on TV; infrequent users find an awful lot of it completely unintelligible.

Boredom was a problem found by newscasters during the two months before the Gulf War. In the countdown to the January deadline they grew to *need* this war to conform to the ordinary rhythms of television (and it was with a hollow air of surprise that commencement of the slaughter was announced).

Time in the TV world is a peculiar thing; it does not wander as life wanders, or pause as life always pauses. The present is only the moment for holding you

THE FIRST CASUALTY OF WAR IS THE FILM RIGHTS

"...Mrs. Smith, about the importance of Family Allowances...."

in place for what comes next. The future counts only as continuation, the past does not matter at all; urgency is in the instantaneous and hence immediately superceded. The technology of transmission even sits unevenly with the advertisers' need to implant the desire to go and consume something else, which is why they need to repeat their ads so often—it also accounts for why millions turn off 'educational' and 'informational' programmes in favour of soap serials, with their familiar characters in endless but regular and connected situations.

We get delivered straight to our living rooms the newest news every day, now, this minute, as each news bulletin consumes the one before it. Images are no sooner presented than replaced by more infotainment in a void, having no connection to past or future, only an illusory present-time. Through immediacy, fragmentation of reality is guaranteed. This is important, for outrages committed by governments can be shelved to a later date where they become reproduced as a redundant history that has been and gone, therefore safe to show, rather than events which we might be tempted to make active decisions on. The delay in transmitting the exposure of British arms deals with Iraq or the cancellation of Ken Loach's Irish drama 'Hidden Agenda' after the Warrington bombing being two examples among thousands that could be picked out. The complete package of lies presented during the Gulf War has since been faithfully documented by the very same media that originally vomited them up.

> "As long as miners are not on strike there are lots of programmes which back up the miners. But if there is a struggle, one which shakes things, then it is much more difficult to get programmes shown which expose the employers. Which Side Are You On was regarded as too political. Yet it could be shown after the strike—it was no longer going to have the same impact."
> Ken Loach

Information is disseminated in such quantity and at such speed that confirmation becomes impossible. Television's imposed world view comprises a thousand and one fragments where anything equals anything else—what counts is the primacy of television which will keep on going even after you turn it off. It is a kaleidoscopic device that ensures no one learns too much. An obsessive frenzy of attention is organised over the most banal of problems ("never mind the politics, was he wearing his *own* hair?"); a frame later grand and graphic theories elaborate sweeping and arbitrary models of development, environment or history. The earth and all its peoples are flattened and rebuilt to fit virtual media reality.

GRAND LARCENY 93

Events are isolated and made to stand, fall, sit up and beg according to media definition. The epitome has to be Dan Rather's live report from the Berlin Wall on November 9 1989 when he told viewers, ''History is taking place before your very eyes''. Such 'journalism' is sports commentary, making it no more and no less an event than the furore over Diego Maradona's World Cup ball-to-hand shake; emotional and super-fluous, something like discussing economics by only covering bank robberies (or BCCI fraud). This emotionalism has its roots in a necessary transitory news sensationalism—the isolation of experience from its context and then its dramatic exploitation. Information is offered up as pure inexplicable significance.

Sure, we live in an 'information age', but does that mean we are better informed? ''This is supposed to be a war for freedom,'' moaned Robert Fisk in the Independent about the Gulf War, ''but the Western Armies want to control the flow of information''. For the TV viewer though, despite sanitisation of the massacre, there was a mindfield of information, from ex-generals, military spokesmen and conjecturing correspondents telling us more than we ever wanted to know about 'smart' weapons, stealth bombers, Scud, Cruise, Patriot. We were not so much convinced of any moral justice on the part of the 'Allies' as exhausted and saturated into submission. What *did* the critical reporters want to show us—dismembered bodies, mutilation? Ah, sweet pornography of death. Breathe in and smell the New World Odour.

What manna from heaven for the broadcasters when the Pentagon supplied the hair-trigger videotapes of bombs dropping from the skies. Even the lack of blood and guts could provide plenty of mileage for discussions of 'hiding the realities of war'—as if we're so fucking ignorant to think war could ever be anything but a festival of mass murder.

War can be something of a tricky one for television. War movies are neat, but 'the real thing' does not *always* go better with Coke:

Pride in Genocide

IN EARLIER YEARS, the statements of Italian dictator Benito Mussolini's son Vittorio, a bomber pilot in Italy's attacks on Ethiopia in the years before World War II, were held up as the epitome of the inhumanity and degeneracy of fascism. In his book *Voli sulla ambe*, published in Florence in 1937, Vittorio referred to war as "The most beautiful and complete of all sports." His most famous line was "It was diverting to watch a group of Galli [Ethiopian tribesmen] bursting out like a rose after I landed a bomb in the middle of them."

The word "beautiful" appeared regularly in U.S. network TV coverage of the U.S. ("allied") bombing of Iraq on January 16 and in the days that followed. Tom Brokaw bubbled over with enthusiasm at "the threatening beauty of it" and a CNN reporter in Saudi Arabia spoke of "the most beautiful sight" of the bombers taking off on their missions of glory. As Brent Sadler saw it on ITN, "The night sky was filled with the star-spangled display of threatening force." Jim Stewart of CBS News referred to "two days of almost picture-perfect assaults," and Charles Osgood of CBS found the bombing of Iraq "a marvel."

"It's a remarkable sight in the window here . . . a beautiful red and orange," announced Holliman, as he described the consequences of the bombing. He then remembered that he's supposed to be a journalist, not a poet, and in what I can only assume was a bizarre effort at *impartiality*, went on to talk about the "beautiful tracer fire."

Ethical Cleansing

"TV lost revenue in the first week of the war when ads were dumped for reporting or pulled by companies that didn't want their products sandwiched inbetween bombing raids. Advertising Age estimated that in the first two weeks of the war, CNN, whose war coverage was among the most popular, lost about $500,000 a week."

Index on Censorship 4+5/1991

To cure the problem an upbeat tone to coverage was adopted which not only retained the rental of the jeopardised advertising space but helped to sell the war as commodity spectacle too. (Maybe next time around they can sell advertising space on the bombs; soft drinks and *cola*teral damage).

News is manufactured to fit into the pre-existing dynamics of newsworthiness, always to serve in the reproduction of alienated relations. Complex realities are reduced to the level of personalities and packaged as self-contained 'newsbites'—the Gulf War becomes Norman Swarzkopf and his 'theatre of war'. All collective movements must be individualised into one leader to qualify as newsworthy, and if there is no leader, why, they'll create one. Gitlin's superb "The Whole World is Watching—Mass Media in the Making and Unmaking of the New Left" describes how the media shaped the image of this movement for the American public according to their function of 'star'-making (the movement then adapted itself to fit the televised image).

You'd be pretty surprised if in real life a starving child, a McDonalds clown and Princess Anne popped up in front of you in quick succession. On flat-earth TV we suspend our *dis*belief almost without thinking because television always presents itself as 'the most real' reality. As Nick Ross and Sue Cook write in their book about being presenters of Crimewatch UK: "For some extraordinary reason people only believe their experiences [in witnessing a crime] when they see something on Crimewatch". It's a pretty long fall down the reality gap when the only reference many can find in experiencing real-life tragedy is along the lines of, "It was just like in a movie".

> "I thought about those mice and rats in behaviourist experiments. Viewers too are rewarded on cue, with a touch of colour, a bit of excitement, a laugh or two, some sex—a good recipe for any show. At the end of it there isn't anything left, it's all empty, except to say, "We ran the rats through the mazes".
>
> <div align="right">The Lancaster Bomber</div>

Through disconnection and confinement, stories arrive from nowhere and disappear back there again forever. Once a news report has served its primary entertainment function programmers charge onto something else. It is exhausted in the moment of its utterance—even if we videotape it, it's no longer 'current'*. If it were a *material* product it would be necessary to throw it away. Where does that leave the viewer? Does it just go in one ear, or eye, and out the other? Well, yes and no. In San Francisco a survey was carried out to discover how much people remember of what they see on TV. Two thousand people were telephoned shortly after the evening news and asked to list as many of the news items they had just seen as they could. More than half of those who watched the whole programme could·not remember even one. It's quite reminiscent of motorway driving, where you have no memory of the last ten minutes—or was it miles?—of your journey.

> "Observing human practice is irrelevant if one cannot catch up with the point of the effort. So much effort is required to remain 'in control' of the continual permutations that usual cautions about **control** slip by. One watches in the hope that what has been obscured will eventually become clear."
>
> <div align="right">Milwaukee Access TV (U.S.)</div>

HEY! IF WE'RE GONNA HAVE A DISPOSABLE SOCIETY...

...CAN WE WASTE THE ROYAL FAMILY FIRST?

The 'Mulholland' experiment in the early 70's wired ten kids to electroencephalograph (EEG) machines (which measure brain wave activity) and sat them down in front of their chosen favourite programmes. He expected to see plenty of fast beta waves, which would indicate that they were actively responding to something (as is produced when reading or during conversation); instead all he could find were the slower alpha waves of the kind found when a person is in a coma or put in a trance where the subject is not

* The notion of 'currency' carries with it a necessary redundance for all that has passed before. Knowledge becomes a highly perishable commodity of transient utility. If we are to talk about how we live we are expected to talk only of what is deemed to be 'happening', in the news, today. All who wish to communicate by written or spoken word are forced or acquiesce in orientating their attention upon the latest issue, event or fad. As the definition of 'importance' changes daily we either go with this meaningless flow or appear hopelessly out of date.

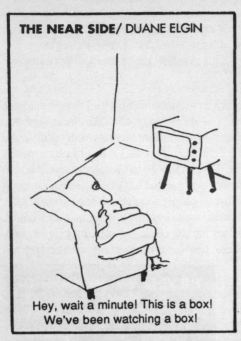

Hey, wait a minute! This is a box!
We've been watching a box!

interacting with the outside world at all.

Maybe this could be explained away as habituation to a repetitive format. Further research found the closing of our minds as emanating *from the machine itself*. In our normal conscious state, the right side of the brain absorbs whatever images come in and whatever emotional associations these may have, while Area 39 of the left cortex provides the logical analysis and integration necessary if we are to make any sense out of the images and put them to practical use. It was found that the left brain can be lulled into stasis by repetitive stimuli such as flickering lights or TV signals. It stops processing the incoming stimulus because it does not seem to be of any use. The right brain soaks up the images like a sponge and, apparently, it goes in and stays in—not as comprehension but as emotion—later on ''you're doing things without knowing why you're doing them or where the motivation came from''.

"This is life. This is what's happening —

"Heavy TV viewers are more likely to overestimate the proportion of the general population involved in police work. They are more likely to overestimate the danger of their own neighbourhood. They are more likely to have a sense of fear about daily life. They are more likely to overestimate the probability of being involved in a violent crime. While many adults may be aware of the fictitiousness of TV, it is hard for many people to distinguish between the real world in which they live and the TV... while people are aware that events portrayed on TV are not 'really' happening, they believe that TV accurately indicates that such things happen, how they happen, when they happen, where they happen, and to and by what sort of people they happen. Thus they develop mental sets modelled on the TV portrayal of reality. As this conception of reality is shared by their peer or reference group, it has real consequences for their lives".

Ontario Royal Commission on Violence in the Communications Industry 1976

— We can't switch to another channel"

Nobody would deny that TV ads are made in order to persuade people to buy things. Presumably this is what they do, or companies would not spend such huge sums making them and having them screened. One of the winners of the IPA Gold 1992 Effectiveness Awards was the Haagen Dazs ice cream-as-sexual experience ads which cost £500,000 and increased sales by 60% over a period of a year.

It seems the stereotypes presented for consumption and the images of success and failure *are* being internalised. On 27 February 1986 14.4 million people tuned into East Enders and watched Angie try to kill herself after she found out her husband had been screwing around again. At Hackney Hospital in East London the total number of deliberate overdose cases

admitted during the following week went up by 300%. Later that year, in November, Angie and Den tried to get their marriage back together by going to see a marriage guidance counsellor; the National Marriage Guidance Council recorded a 50% increase in the number of callers in need of their services. In this instance is the emotional force of the action increased through personalisation and familiarity? Would the same effect be found through televised coverage of riots? Apparently, to some degree, yes; as reporting of riots has been subject to blanket bans to forestall 'copycat rioting'. That, as the loony right suggests, television can create a *culture* of rioting, is very much in doubt. There does seem to be more basis to the belief that we can be made to salivate on cue for ice cream,

People on TV merely acting

TV GUIDE (IP) – Interest groups issued a trance-breaking public reminder today: people on television are paid to act the way they do.

"We tend to forget that TV is a fiction with no beginning, middle or end," the public reminder said in person.

blood or Baronness Thatcher's head on a stick and might act on advance publicity on the likely occurrence of rioting. It's more likely though that we'd stay home in the hope of watching the whole thing, with replays, on TV. With any luck, the revolution *will* be televised.

The 'revolutions' in Eastern Europe certainly have been played out more on the screen than the street—most of the battles that have occurred between the old and new bosses have been for the television stations. The image has become the predominant mode of public address. In Romania, the new rulers were inaugurated live on the box; the State Television station which hosted the show adapted itself seamlessly to the new conditions:

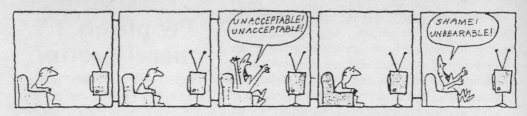

"We beg forgiveness for our mistakes over the last 25 years, and we will now compensate by bringing you the truth." Revolutionary announcement by Petre Popescu, Head of News

Today, business has returned to usual and the political situation stabilised. Television continues to be a tool for control, but with a new caste of exploiters* (fittingly, a large number of them from media and cultural professions). By January 1993 the independent stations that sprang up during the leadership struggle in Romania had all had their operating licences refused, in order to make way for a company that intends to pipe in CNN 20 hours a day.

TV constantly imposes images which in their immediacy and directness impede conceptual thinking. It inhibits thought by inducing us to live, mentally, in a world of arbitrary and fragmented definitions and automatic ideological equations. By encouraging us to accept ready-made ideas it is fostering in its viewers a mental passivity manifest in purely emotional activity (such as impulse buying). Sure, take your desires for reality; just make sure they're your own. Can television teach us to be radical? Though we may all suffer from mass illusion, there is no formula for *mass disillusionment*; all efforts only embroider our illusions.

"An antiwar film is generally assumed to have a 'powerful' effect if it presents a barrage of the horrors of war. The actual subliminal effect of such a barrage is, if anything, pro-war—getting caught up in an irresistible onslaught of chaos and violence is precisely what is exciting about war to jaded spectators. Overwhelming people with a rapid succession of emotion-rousing images only confirms them in their habitual sense of helplessness in the face of a world beyond their control. Spectators may be shocked into a momentary anti-war revulsion by pictures of napalmed babies, but they may just as easily be whipped into a fascistic fury the next day by different images—of flag burners, say." Bureau of Public Secrets

* In the former Soviet Union, the Pro-Parliament dissenters, outlawed by TV decree and trashed by Yeltsin and his generals in Moscow in October 1993, had three demands: "The blockade of the White House must be unconditionally lifted; the constitution of Russia must be restored; and the organs of the mass media must be opened up for all political forces. Control of the media, particularly television, by one group—as we have now—is intolerable" (Morning Star 4.10.93). Yeltsin's democratic broadcasting system consists of the freedom for other parties and organisations to buy airtime from his appointed TV henchmen for around £400/min. Yeltsin himself, as a matter of course, gets it free.

GLOBAL BROOKSIDE

"Truth is the revelation of that which makes a people certain, clear, and strong in its action and knowledge"

Heideggers's pro-Hitler declaration 1933

Television delivers unto millions the same images from afar, while reinforcing the separation of individuals from each other. It is the perfect adjunct to our modern urban atomisation where 'community' is very much a non-supportive constituency of social pressure and little else.

"I'd love to stay and listen to this fascinating conversation all night, gentlemen, but unfortunately I have to wind it up now and go to bed"

Television fills our isolation with the dominant images—images which derive their power precisely from this isolation. As our opportunities for personal interaction decrease, in turn our reliance on television for making sense of our existence increases. Slice of life soap in your eyes dramas have become raised to the status of basic need; we devour all media in the hope of some clue, some recognition of meaning to our lives and captive experience. What do we get? A shared community always *else*where, substitute for the lives we have ceased to live. Television brings us 'together' in individual family units to view what 'everyone else' believes, under the guise of 'giving us what we want'. Hooked by every lie and sitcom, we are nurtured on pulp about life in other fictional suburban settings—everybody needs good Neighbours now that we don't know who lives next door.

Certainly it's true that television 'links' those who are too physically or socially distant to be in touch with each other; almost instantly we can view events that may be happening in countries thousands of miles away. But what can we be sure of as having took place there? Why are we consuming this information and what are we going to do with it? Are we becoming consumers of struggle and voyeurs of distant revolutions?

"...the Left: a mass of spectators who swoon with rapture each time the exploited in the colonies take up arms against their masters, and who cannot help seeing these uprisings as the epitome of Revolution... when it bewails its situation and complains about the "world order" being at variance with its good intentions, it is in fact attached to this order—the apparent opposition of systems is its universal frame of reference: wherever there is a conflict it always sees Good fighting Evil, 'total revolution' versus 'total reaction'. This whole fine lot does not actually fight what it condemns, nor does it know that of which it approves. This opposition remains spectacular for everyone. Those who were really opposed to Spanish fascism went to fight it".

Internationale Situationiste #11/1967

"Too busy fighting your irrelevant battles," sang Patrik Fitzgerald, "to see what's going on in your own backyard".

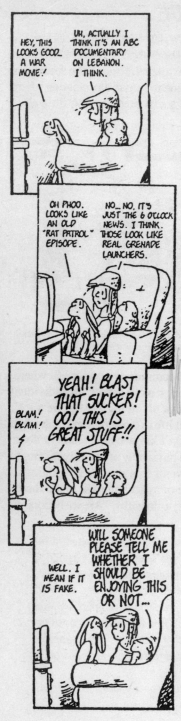

As a method of communication, the mediation of contact through machinery has *extended* the distance between sender and receiver who might otherwise have been in closer personal contact. This distancing attaches a mystery to the technology, from which the communicator benefits by association: because television is so highly centralised, and involves so few people in production, it appears remote and inaccessible (who makes the programmes and how?) giving itself a spurious glamour, making the stars brighter and the specialists more special, real, even friendlier than ordinary people. Day after day we are confronted by *top people* who say and do *important* things, who *know the answers* and live *successful* lives. These are your leaders it's inferred; isn't real life best left to them?

By enlarging our reception of images and messages to encompass the whole 'global community', television actually confines experience to the non-lived which it is free to manipulate. A closure is made on our opportunities of knowing. For broadcasters in the Third World, dependence on the international news networks has meant that an event taking place in a neighbouring country, or even another part of the same country, is broadcast only if the supplier chooses to do so. How does that compare with this country?

The 'important' events and unverifiable stories, the wars—indistinguishable from the war movies—and the banal scandals we are bombarded with have not been lived by us. What use is this rush of information about an *other* world we do not know and even less likelihood of affecting?

Everyone says "You shouldn't believe what you see on TV" but often we have little alternative but to believe it. The reality delivered to us is *known*—because this is the only space where anything can now be publicly affirmed; and *true*—because it's the only thing we've all witnessed, so must be trustworthy. Against what could we measure its truth. The daily papers? 'News'papers routinely devote over half their column inches to promotion of what's on TV, what's been on TV and what people off TV programmes (fictional or otherwise) are saying, wearing, doing, screwing.

Those who give us the 'facts' of reality engineer themselves into the position of being the only ones who can make sense of them for us. Television may have broken the parental and school monopoly on managed information, but only to create its own. Counter-information—that questions even its own affirmations and serves no master—is of course available, but only for fanatics; fanatics because we do not have, and do not want, the power to impose subjectivity as imperative truth.

NODDING DOGGY STYLE

"A new source of viewers could be at hand however. Some eight and a half million people say that their pets are watching more television than ever, with about half describing them as 'active viewers'." Times 27.8.91

Time spent sitting in front of the telly cannot be given over to anything else. Why read between the lines to deconstruct the manipulated knowledge about a life you stopped living as you sat down to watch? Sure, neither is writing or conversation a transparent window on the world. They are a map; maps obviously differ from the area they describe, they are its representation, through which we can recognise nevertheless the terrain in question. What someone says or writes is taken with a pinch of salt because conversation and the written word is easily discerned and understood as *subjective*. Filmed footage demands for itself an imperative "truth". No matter what anyone may have said, "the bastards" were indeed "torturing our boys" in the Gulf when the BBC screened the pictures of the battered faces of captured Brit flyers Lieutenants John Peters and Adrian Nichol. (Peters' wife was given the full version of the video by 'visitors' on condition she kept quiet about it. On the un-broadcast tapes her husband told them he was fine and his bruises had occurred when he ejected from his aircraft. The Dispatches series wheeled out the 'made for TV' version again just before the re-introduction of the Iraqi no-fly zone).

The image operates upon us in a manner which conceals its ideological function because it appears to record rather than to transform. Its power lies in its visual character as an actual trace of reality, the evidence of our own eyes—'this really happened, see for yourself'. Television deals above all in manipulating emotion, with no time for reflection; we are made to feel part of the event because millions are seeing it at the same time. It is a constant mental battle to remind ourselves that the electronic image is an illusion created through its manufacture, the editing process.

Harvard University research group set out in the early '80s to compare ways in which children respond to what they read in a book and what they see on television, by presenting exactly the same material to two groups of children. One group simply had to sit and listen to somebody reading them a story while the other group was shown a film in which the same story was read out as the soundtrack and illustrations from the book were shown on the screen. The real-life storyteller and the television narrator were the same person.

TV a turn-off

according to the results of another 13-year survey by scientists at the Universities of Chicago and Rutgers, viewers feel worse after watching television. "The longer a person watches the TV set, the more drowsy, bored, sad, lonely, and hostile the viewer tends to become," says the report, published in a book, Television and the Quality of Life.

The survey was based on a prolonged sampling of 1,200 people, ranging from the ages of 10 to 82, who were asked to write down how they felt each time a buzzer went off. Although many of the participants said they watched television in order to relax, the survey found that they were more relaxed before they switched on their sets than after viewing.

"These facts are particularly important because they tell us a person need not reduce concentration and feel passive in order to experience relaxation," say the authors, Dr Robert Kubey and Professor Mihaiy Csikszentmihalyi.

GUARDIAN WEEKLY, May 13, 1990

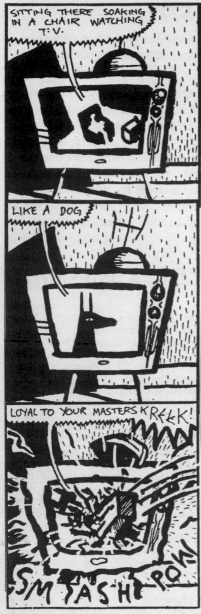

The book group was found to have taken in a good deal more of the story than the TV group. They could recall whole chunks of it verbatim as well as several details, whereas the TV group showed that they had absorbed the images, left most of the words behind and couldn't speak much of what they had seen. The TV story was accepted as what the project described as a 'self-contained experience'—images with little connection to anything else. Children in the book group were much better than those in the TV group when it came to discussing, conceptualising and even abstracting from the story. The results seemed to indicate that it is not the content of a TV programme that affects viewers negatively but the medium itself. TV is a lazy medium through providing all the images for us (someone else's) and by suppressing ''inferential reasoning'' creative and imaginative thought becomes impossible.

Broadcast programming compounds this disconnection. It is constantly in flux—if we disagree with something we can't go back and reconsider it. In conversation, in reading, we take the elements of what is said or written as well as the utterence as a whole and translate it in our minds into another active and responsive context. When we watch television we have no opportunity to take part in the discourse; it allows no reciprocal (give and take) action between transmitter and receiver. The ability to respond on equal terms at the pace of our own intellect is denied us and we are lulled into uncritical consumption of the assumptions and connotations made. If we do disagree, we have only the democratic right to turn off. Only one party to the relationship initiates the communication, that same party gets to illustrate the talk, and before it comes to questions at the end time, they rush on to something else. It's a modern-day Nuremberg rally; it's like discussing politics with someone with a technicolour megaphone and schooled in fast-talking, who has put the receivers into 50 million separate isolation booths. The bark of the producer is amplified to an overwhelming roar against which the supervised consumer can barely whisper. And with the right pictures you can prove anything.

Are we being systematically brainwashed by images of immense mental power over which we have no control? And are we being forced to watch? Or to put it another way: have we got any choice? Is anyone in our 'information age' society outside TV, beyond its compulsions? TV licence snoopers now work on the premise that every household must have a TV—if you

TV simulation ordeal for Koresh

THE FBI is blasting out a tape of the whine of a dentist's drill to keep the cult leader David Koresh on edge in the siege of Waco, Texas, now 46 days old, *writes Hugh Davies in New York*.

A spokesman for the FBI – which has previously tried the chants of Tibetan monks and a bugler playing Reveille — said the sound was used for its "irritation ability".

The drill is being accompanied by the peal of bells, pinballs clanging, dogs barking, cows mooing, cocks crowing, a train crashing through a building, the squeals of rabbits being slaughtered and Nancy Sinatra singing These Boots Are Made For Walkin'.

Daily Telegraph 15.4.93

ain't got a licence for one, it follows that you're trying to watch for free. So you get a visit (and not to bring you unedited war videos starring your husband). We are surrounded and worked on from birth to be passive consumers, at the receiving end of initiatives originated remotely and conditioned into internalising the media's ways of seeing. Although it is perfectly possible to decode TV messages, disagree with them and reverse their ideology, it is not the case that we are free to decode as we wish. Oppositional readings are dependent upon an ability to make an accurate decoding in the first place. ✳ decoding mess. transmitted.

"The objection that we overate greatly the indoctrinating power of the media misses the point. The preconditioning does not start with the mass production of radio and television and the centralization of their control. The people entered this stage as preconditioned receptacles of long standing."

Herbert Marcuse

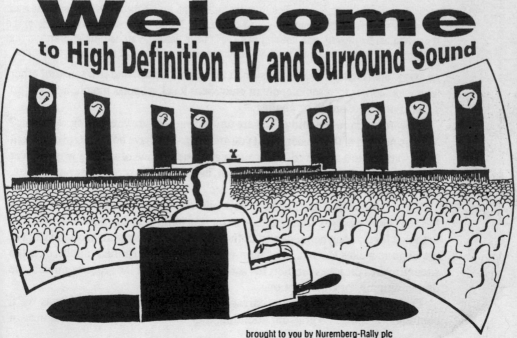

Welcome
to High Definition TV and Surround Sound

brought to you by Nuremberg-Rally plc

in association with Euro Misery.

ALL THE WORLDS A SCREEN

Sometimes it's nice just to come home from work, put your feet up, switch on the telly and relax...

You start watching a programme and pretty soon, a crisis occurs, though not a crisis in *your* life. Which is a relief, you can take it easy then, can't you? Or can you? Charlie the dog is getting run down by a car in Neighbours, Sharon's punched in the face in Eastenders, Chernobyl victims are counting the cancers they've got now. And those poor kids in Bosnia have just got lacerated with shrapnel... again.

Some of these crises are fun, there's a nervous excitement about them, even though you know nothing terrible is *really* happening—after all, they're actors, aren't they? Other crises are just plain terrible already; these tend to be the ones that claim to be accounts of reality.

Perhaps you could change channels. Now, sport—that's exciting. You can't fault that. But the tension is still there. Crisis remains ever-present. The experience is a continuous build-up and release of tension, it ebbs and flows but will not totally

A great thunderstorm of sound gushed from the televisor walls—he felt his jaw vibrate, his eyes wobble in his head. He was a victim of concussion. When it was all over he felt like a man who had been thrown from a cliff, whirled in a centrifuge and spat out over a waterfall that fell and fell into emptiness and never—quite—touched—bottom—never—no not quite—touched—bottom—you fell so fast you didn't touch the sides either—never—quite—touched—anything.
The thunder faded. The music died. "There," said Mildred.
And it was indeed remarkable. Something had happened. Though the people in the walls of the room had barely moved, and nothing had really been settled, you had the impression that someone had turned on a washing machine or sucked you up in a gigantic vacuum...

go away. Sport makes good television, it thrives on 'crises' and in a sense all other television comes to resemble, on an emotional level, a sports match, a 'team' to support and a 'team' to be against.

You are sat there watching. You are unwinding—or are you getting wound up? You are not part of the tension—but you are tense. You have no direct involvement in it—but you are on the edge of your seat. A tidal wave of stimuli washes over you—do you absorb any of it? How much, and what? On screen, they are living, they are planning, they are loving, they are crying. We... well... we're *watching*.

We sit, concerned, excited, all the while responding emotionally to what's flashed before our eyes. The image of a starving child is much more heartrending with that lovely song being played in the background; the zoom-in on the tears of the victims makes the *image* of pain more intense; the canned laughter on the sitcom makes the jokes funnier; the sober, moral tones of the reporter moulds the proper opinion for consumption.

The experience is an endless barrage, exciting and seductive. This way we'll continue watching. To grab our attention, they wrench us from the mundanity of

THE ONLY WAY THIS CAN BE DISSIPATED IS BY RESOLUTION OF THE ORIGINAL CAUSAL CRISIS

everyday life by our emotional heartstrings, to relate to pleasure and beauty, to reel away from pain and suffering. The pitch of this emotional battering is kept feverishly high, way beyond the levels one could expect to experience regularly in daily life.

Unlike lived experience, where we choose how we react, with television it's hard *not* to respond in the prescribed emotional manner. Every image, every sound-bite is tailored to what the programme makers want us to experience, the way they want us to feel while we're watching.

Emotion tends to be a rare thing in our daily lives. We plod on, detached and 'level headed' as a way of coping with the ways we're forced to live. If we do for a moment consider our lives on an emotional level, we find them lacking, not matching up to the glossiness of those on television.

In most cases we tend to suppress our emotions. To be overtly 'emotional' is seen as a bad thing. We find it hard to tell those we do care for emotionally how

What's on this afternoon?—he asked tiredly.
She didn't look up from her script again—well, this is a play comes on the wall-to-wall circuit in ten minutes. They mailed me my part this morning. I sent in some box-tops. They write the script with one part missing. It's a new idea. The home-maker, that's me, is the missing part. When it comes time for the missing lines, they all look at me out of the three walls and I say the lines. Here, for instance, the man says, 'What do you think of this whole idea, Helen?' And he looks at me sitting here centre stage, see? And I say, I say—she paused and ran her finger under a line in the script. 'I think that's fine!' And then they go on with the play until he says, 'Do you agree to that, Helen?' and I say, 'I sure do!' Isn't that fun, Guy?

we feel about them. We find it hard to express our anger about the way we're being treated. Instead it all builds up inside, only finding release in the eagerness with which we 'involve' ourselves in television's emotional agendas.

Within the confines of our daily lives, nothing seems to quite match the excitement of the telly. The people we relate to don't display the drama and passion of the skilled actor. Even the television programmes themselves become tame, the problems of the world tiresome and we are numbed into insensitivity by an over-saturation of emotions.

If we switched off the television, we might just start to look at each other again as real people, genuine, vulnerable, fragile humans. Each of us emotionally wounded by cruel conditioning and oppressed by the figures of Baywatch-style beauty.

The televison people will never have the life and strength of those who have suffered, those who are capable of loving enough to really hate, those of us who are longing for our emotional desires to be realised, realised in our own lives rather than in the sad representations that television offers.

THAT IS, BY CONTINUING TO WATCH THE TELEVISION

EVIDENCE? THE VIDEO PROVES NOTHING.

WINDOW SHOPPING

"Minority victims of past police misconduct have said the only difference between their cases and that of Mr. King was the camera" New York Times

Despite the illusion of full-immersion "actuality" provided by the minicam and the helicopter, television's coverage of the riot's angry edge was even more twisted than the melted steel of Crenshaw's devastated shopping centers. Most reporters—"image looters" as they are now being called in South Central—merely lip-synched suburban clichés as they tramped through the ruins of lives they had no desire to understand. A violent kaleidoscope of bewildering complexity was flattened into a single, categorical scenario: legitimate black anger over the King decision hijacked by hard-core street criminals and transformed into a maddened assault on their own community.

On teevee
 see the looters run
With whiskey
 and cartons
 of cigarettes,
With wigs
 and sofas
 and teevee sets—
Running
 after
 the merchandise
All the
 commercials
 advertise
 on teevee
 on teevee
 on teevee

Apart from the video of his beating, King has been allowed just one more TV appearance; that came two days after rioting started - "Can we all get along?" - fit the needs of the system perfectly as a rallying cry for a return to the 'social peace' before the riot. Such a fine slogan, it was plastered on billboards all over south-central Los Angeles.

A CHEAP HOLIDAY IN OTHER PEOPLE'S MISERY

BODY EQUIP

At the Chicago riots of 1968, the demonstrators shouted, 'The whole world is watching!' And the whole world was. What they were watching was first-rate TV drama and they hadn't the slightest interest in translating this into response.

AT THE HATE FACTORY

During the revolt, the media creeps latched onto the video footage of the beating of a white truck driver, Reginald Denny, rebroadcasting footage of this largely atypical incident hundreds of times in order to tar the revolt with the stigma of a race riot. The subsequent rescue of Denny by several black people was not shown quite as often. Towards the end of the riots, the people who rescued Denny, naively, crassly or stupidly accepted awards for their rescue from representatives of the local business classes. This allowed their aid of the injured man to be deputized by the local commercial classes in their effort to assert proprietorship over 'humanitarian' acts, and by implication, indicting the riots as a completely psychotic episode or pogrom.

oh yeah - there has been a change: Police Chief Daryl Gates has resigned, to become a radio talk-show host, his autobiography is selling well and he's being consulted to develop an L.A cop computer game

Outside the court, the trial at times seems more like a sporting event than a legal hearing intended to address one of the most emotive racial issues in US history. The top-security court in downtown Los Angeles is teeming with legal experts and glossily dressed television reporters spouting up-to-date "analysis" of Mr King's performance.

One observer in LA exclaimed, "These people aren't like looters. They're like game show winners." One woman cried gleefully as she carted off a handful of clothes from a looted store, "This bargain basement! Bargain basement!"

Rodney's aunty produces the T-shirts, is planning a book of her own, and meanwhile moans that his ex-lawyer, Stephen Lerman has signed up to do a film and some publishing.

Latasha Harlins. A name that was scarcely mentioned on television was the key to the catastrophic collapse of relations between L.A.'s black and Korean communities. Ever since white judge Joyce Karlin let Du off with a $500 fine and some community service—a sentence which declared that the taking of a black child's life was scarcely more serious than drunk driving—some interethnic explosion has been virtually inevitable. The several near-riots at the Compton courthouse this winter were early warning signals of the black community's unassuaged grief over Harlins's murder. On the streets of South Central Wednesday and Thursday, I was repeatedly told, "This is for our baby sister. This is for Latasha."

It is abundantly clear that those charged with beating Reginald Denny are being crucified by the mass media and the government as punishment for their symbolic 'guilt' for the whole uprising. As usual, the commercial media have presented a highly skewed picture of the beating (without investigating events leading up to it in the area, including an immediately preceding police beating of the neighbors of one suspect), while the government at all levels is crusading for a quick and simple legal lynching. In contrast to the assault charge filed against the gang of cops who devastated Rodney King, Damian Williams (19), Antonine Miller (20) and Henry Watson (27) were each charged with attempted murder, torture, aggravated mayhem and robbery. At the arraignment of Damian Williams, L.A. police chief Gates placed the entire LAPD on full tactical alert, in a melodramatic gesture similar to Gates' personal media-orchestrated arrest of Williams in the company of 200 cops and FBI agents. Williams' bail was then set at a level six and a half times that of Rodney King's LAPD assailants. When his mother was able to raise the money, the U.S. Attorney prevented his release. And while defense lawyers contested this, 37 new felony charges were filed against him and his two co-defendants. Bail was increased to $580,000, almost 20 times that of the Rodney King assailants. When Damian Williams' mother, with widespread support from the outraged black community was coming close to making this new bail amount, court began special proceedings supposedly to determine whether property used for securing bail was "acquired legally," and the D.A. began videotaping Damian's family and supporters. For a more complete account see Mike Davis' "L.A. Was Just the Beginning" (*Open Magazine*, POB 2726, Westfield, NJ. 07091).

ThOuGhTs On TeLeViSiOn?

It doesn't matter what's on the screen. Extensive dissection of media 'coverage' of the Gulf War is only a recent notable example of an ongoing process of criticism of propaganda in broadcast television. The problem with this criticism, for all its truths about the omissions, distortions and falsifications, is that it tends to reinforce the obsession with viewing itself. And it legitimises the false distinction between 'good' and 'bad' television, sustaining the idea that

television is reformable.

The informed and critical viewer is necessary to television, s/he makes the intolerable falsehoods more tolerable, more watchable, by deconstructing them as s/he watches. The aggravated viewer is also the happiest—you are supposed to get angry with your television. It is safe.

forced activity

—for example waged work—is likely to be boring, but is, after all, **forced**. Leisure time is meant to be your own *free* time; time you have *earned*. It is dangerous for this time to be too boring. Television makes boredom (that is, the fact that daily living is boring) tolerable. Television occupies and so distracts. By absorbing attention and time it allows us to refrain from considering the state of our lives.

Watching television is an 'activity' only in so far as it excludes the need to act. It requires no effort, no input, it makes no demands. It is entertainment for those too drained to entertain themselves. Television assumes this role with ease, because the identification of leisure with indolence, with the absence of work or of any activity at all is strong for people who have to submit to the demands of forced work,

wage labour.

In this way, television complements and reinforces a wider state of affairs. It reflects and underlines our 'normal' day to day experience of

powerlessness, enforced passivity, lack of voice

We spend all day following orders, putting up with things and making do. Little wonder that in the evening we tune in to whatever is on offer, submit to ideas, opinions, images to which we have no means of answering back, and choose between the non-choices of different programmes or channels.

Television as a medium, may not in itself be a problem. An empowering, participatory television may be possible (maybe). But anyone who tells you that technology is 'neutral' is a fool (at best). It is not by accident that television has developed and proliferated to become the dominant media in our lives. It is because it is the media most closely suited to serve and promote the requirements of a social order that functions against us. Even if all you want is television that is not malign—and I want much more than that—the first unavoidable step is clear:

turn the damn thing off

from SIC zine, folder 19, 30 silver st, reading

WATCHING BIG BROTHER WATCHING YOU

> "What characterises the mass media is that they are anti-mediators... Television, by its presence alone, is social control in the home. It is not necessary to imagine this control as the regime's periscope spying on the private life of everyone, because television is already better than that: it assures that **people no longer talk to each other**, that they are definitively isolated in the face of statements without response."
>
> Jean Baudrillard

Television is a determining factor in the increasing privatisation of social life, along with products like the private motor car and structures such as out-of-town shopping centres, all made possible through Western capitalist abundance (at least for a sizeable number). In all these things, socialisation into self-sufficient family homes and the highly regulated domains of leisure has largely dispensed with the need for continual open coercion (though not constant surveillance by cameras in the streets). Social life—out there—appears increasingly hostile and bizarre on TV *and because of TV*: it was after all closed-circuit cameras and the open sewer in the corner of the living room that brought us the pictures of Jamie Bulger in a Bootle shopping centre getting led away by two ten year old children, to his death. We are insulated *and* involved in social life from the safety of our own homes. Television's conjuring trick is to be on the scene and in your front room at the same time, producing and discharging anxiety, stirring up a *frenzy of apathy*, both source and solution to a contact forever deferred.

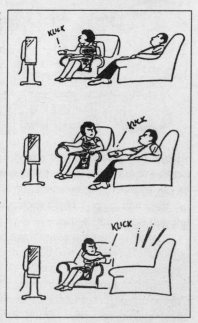

The technology of isolation nightly calls its faithful to ritual communion, to relive as one the traumas and fantasies of the security state outside. As with religion, it is effective insofar as we find in it some matter of our own actual experience—those rare flashes of humanity captured in a passing instant on a box that daily denies it. It is deflection in its incitement to spectate, as we sigh with relief that thankfully ''that's not me'' the victim suffering in front of the camera. In this virtual community, the spectator can view wars as fantasy, cheering for the home team, maybe without experience but certainly with zealous conviction. Detachment from an activity, no matter how horrific, makes possible its easier acceptance.

> "Socially and psychologically repressed, people are drawn to spectacles of violent conflict that allow their accumulated frustrations to explode in socially condoned orgasms of collective pride and hate. Deprived of significant accomplishments in their own work and leisure, they participate vicariously in military enterprises that have real and undeniable effects. Lacking genuine community, they thrill to the sense of sharing in a common purpose."
>
> Bureau of Public Secrets

Yet for every 'thrill'—killing 'Argies', killing Iraqi 'sand niggers', playing PacMan—there follows the horror of its reenactment when we then conduct ourselves in everyday life, utilising what we have been taught to know, from watching others live and die on screen. The high

AWRIGHT PARKER, YOU STASH ANY BODY PARTS IN THOSE TRASH CANS?!

YES! BUT CAN YOU GUESS WHICH ONE?! YOU COULD WIN ONE OF THESE FABULOUS PRIZES! TELL HIM ABOUT THEM DON!

priests of the media are pushing the drug of routine dehumanisation through disconnection. It **must** rebound on all of us at one time or another—the poorest, of course, first; the ivory towers, unfortunately, last.

The root causes to Jamie Bulger's death go too deep for a medium that peddles pure voyeurism. From the box that provides crass explanations for everything as profusely as advertisements for pain relief, there was for once a curious and novel silence. The reason for the silence being that, for the media, there was no obvious scapegoat to point the finger at or demonise (save for two ten year old kids). It was an uneasy and cynical silence broken only by the whispered, gob-smacking suggestion that his death was "inexplicable", as life itself is "unpredictable". There is one thing though that can be predicted with certainty—it will happen again and again.

As soon as the images are worn out, concern for a child's life is wiped out (until the drama of the trial). Next up, two blistering hours of the best of British comedy: Carry on Shopping. The following week, as if merely switching channels on reality, the local shopping arcade (like the distorted funhouse mirror of television itself) plays host to some 'real life' actress from Coronation Street or East Enders, maybe opening a new branch of Mark One or unveiling the latest in-store security system for the Happy Shopper. Why do we have these stars and their sickening one-night stand remembrance services? Is it because some people are so blindingly talented that they cannot go unnoticed and unheard? This may be true of Jeremy Beadle; for the rest, the strategy of concentration on 'gifted' individuals is means for the continued self-renunciation of the majority. In the practical activity of selling our productive self for a wage, for survival, we have alienated ourselves from creativity and all the products of our labour. The world of work (and the eating, sleeping and *past*imes that are designed to support it) is characterised by its routinisation— it is dull, repetitive, certainly a little empty and meaningless.

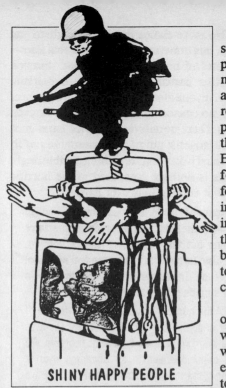

SHINY HAPPY PEOPLE

We sell our bodies and our time to buy back our survival. With creation reduced to its parody—exploitative production—recreation is the necessary convalescence. It is to this yawning void, always dangerously close to being filled in by the revolt of refusal, that the full machinery of mass-produced amusement has been applied. It manufactures the warm comforts of belief, role model and idolatry. Every image a packaged promise. This hollow excuse for a discarded life cannot be maintained forever—joyriders are already one step ahead in introducing play for pleasure's sake into the advertisers' images of status through vehicle possession, ramraiding the very notion of motor*sport*. Alienation can however be intelligently defended by the implantation of desire to associate and share in the reflected glory of charismatic figures of leadership.

We are worshipping Gods again in taking images of humans as objects for adoration (count the celebrities who have believed in themselves as new messiahs); we're encouraged to have faith in their personally extraordinary qualities (watch us buzz like flies on shit to get a closer look when one of them actually appears 'in the flesh'); and we can follow their every move and be part of the new mysticism with concerts, videos, fan clubs, posters and a thousand ready commodities of identification and belonging. Our spectatorship—a result of the rupture of thought, action and feeling in daily experience—makes televised images appear that much more packed with activity and meaning. They portray what is *really* taking place in the world of consequence, played out by larger than life actors, all the men bigger than Jesus.

So well have the concepts of class and collective been banished from social consciousness that some of them actually come to believe in the absurd theatrics the media promotes them with. Some of them really do believe they are the new makers and shapers of history. With the regularity of religious vomit from the mouths of prophets, it's declared that they alone are the embodiment of any possible meaning, consequence, change. There is no longer any collective self-determination, we're told; no actions, other than those of the stars, which could possibly have historical consequences. There is left for the passive majority of never-to-be-famous followers merely the sense of purpose provided by sacrifice and submission on the one hand, spending on the other. Class is dead! Long

IDOLATRY

INTIFADA

WHY ?

because it's profitable...

OR

8 MAY 1983 THE SUNDAY TIMES

Moscow riot police ready for revenge

Major Vitaly Keiko, another swarthy, crop-haired riot police leader, said: "They were like mad dogs." He complained that the police had been inadequately armed. "If only we'd been authorised to use tear gas like they do in civilised countries we would have been able to beat them back like dogs." Another officer said: "Our authorities seem to take the attitude that it is better to risk the lives of policemen than to deploy the proper technology."

YUGOSLAVIA

live class! No more choice between socialism and barbarism in this brave new world order that knows only two states of being: monotony and disaster. Now it's either barbarism... or more barbarism. There are no 'revolutionaries' in the congregation of this church; no conservatives, nor liberals or even reactionaries. There are only *in*actionaries, harangued from the televangelist pulpit to be simply *out of it*.

The continual worry that something terrible might happen to us is nothing compared to the horrific realisation that *nothing* may ever happen.

"In the expanded world of mechanically vivified communication the individual becomes the spectator of everything but the human witness of nothing. Having no plain targets of revolt, men feel no moral springs of revolt. The cold manner enters their souls and they are made private and blasé...

"It is not the number of victims or the degree of cruelty that is distinctive; it is the fact that the acts committed and the acts that nobody protests are split from consciousness in an uncanny, even a schizophrenic, manner. The atrocities of our time are done by men as 'functions' of a social machinery—men possessed by an abstracted view that hides from them the human beings who are their victims and, as well, their own humanity. They are inhuman acts because they are impersonal. They are not sadistic but merely businesslike; they are not aggressive but merely efficient; they are not emotional at all but technically clean cut."

C. Wright Mills, The Origins of World War Three

Is it any wonder then that some try to break out of this spiral of meaningless identification through subjugation, to tear free of the lonely crowds of anonymity by shooting up Hungerford town centre and burger bar massacres? This is the underside of those heroic 'achievements' of icons of perfection that we are bidden to venerate and forbidden to touch or become. A brutalised population devours itself for the deification of the audience. Welcome to the terrordome—next time in **your** shopping centre.

The United Colours of Surveillance

Jamie Bolger Was Murdered By Cameras

The choice lies before us. To pursue social and economic justice, or to install yet more cameras and alarms. Make even more laws. The choice is to give each other human value, or to continue to exploit. The choice is to assert human value, or to assert property value.

Cameras can be no substitute for justice. They merely reinforce the continuation of injustice. To pretend that cameras and alarms are a substitute for justice is to become one with the injustice.

To install cameras is to act, but not to act well. It gives the appearance of addressing the 'problem of crime' (the breaking down of property relations) but not the causes of crime (a breakdown of human relationships). Installing cameras is to do nothing more than to command the continuation of injustice. Jamie Bolger's death was a product of that social and economic injustice.

LIBERATE US FROM OUR LIBERATORS

"Culture as Spectacle covers everything: we are born into it, go to school in it, work and relax and relate to other people in it. Even when we rebel against it, the rebellion is often defined by the Spectacle."

Carol Ehrlich

In the headlong rush to supply information for information's sake, the media has shown willing to admit and dwell on the bankruptcy of the system, convinced that it has demonstrated to all that there is no alternative. It is in this atmosphere of cynicism that we should consider the intentions of 'radical' and 'positive' media coverage.

Television will bend over backwards giving opinions about everything and anything to ensure we have none about the totality. Polls, surveys, market research, charity drives and campaigns enlist the spectators in debates of particular and harmless antagonisms. We are urged to rearrange our ration of one-eyed information by writing to our MP's or buying a Save-The-Latest-Specified-Victim LP, choreographed swinging tunes from the record companies responsible for the multinational mutilation in the first place. Live Aid, Nelson Mandela—and hey new for 93 it's fascism/anti-fascism—it's all good mileage and great company promotion for corporations that supply arms and security equipment to Third World gun law juntas (thereby reaping the profits from special operating concessions, minimal tax obligations and a super-exploited workforce). So good in fact that the Thorn EMI boardroom has awarded itself £7 million worth of directors' salaries. The largest bonus for increased profiteering from radical posturing has gone to James Fifield, head of EMI Music. He's got a special bonus scheme organised, based on profit improvement over three year periods. His fruit machine has come up with a line of clenched fists and he Blagged for himself for 1992 £1,086,000 and clocked up, by the end of June 1993, £1,852,000 which will become payable in the future. Stop making sense— and start making millions.

WORLD TO WIN

DAN DARE

A DISABLED anti "Children in Need" demo on 20 November saw over 70 people blockading entrances to the BBC TV studios in London.

"Disabled children are in need because television portrays them as either pathetic, sad victims or courageous brave heroes. The BBC must put a stop to abuses of this nature. They have not got our permission," stated the Direct Action Network.

DAN, 68 Alexandra Court, Empire Way, London HA9 0QP.

IN THE ANTI TELETHON action in July '92 a 1,000 strong crowd burst from the confines of its barricades and blocked the entrances to the London Weekend TV studios.

STONE HENGE

84

HOMELESS AND A HUNGRY

GRAND LARCENY 93

Artists come and go by the week, the turnover is necessary for the music business to sell maximum units before the punters lose interest/discover the shallowness of the product. Alternative artists that enter the commercial pop arena under the illusion that they can subvert the system or 'rip it off' find that ultimately it is they who are being exploited along with the punters; the major label gains a bit of 'hip' credibility and the band loses theirs...

When you find the door prices at gigs of populist bands hitting you in the pocket as hard as the bouncers hit you in the head, and the record prices rise, remember the bosses at EMI are grateful for your alternative contribution.

'DIY not EMI' leaflet, undated, London [no address]

The military industrial media complex has organised the world for the extraction of profit. Footage of the carnage is passed onto its Department of Spectacles who re-present it for selective outrage. To ease the social conscience there are annual displays of money-collecting for those whom capitalist logic would really prefer not to be alive at all. We support its *continuation*, not its resolution, through bleeding heart taxation (charity donations) or, if we really wanna take a stand, why, pay to dance to a band, commodities of opposition in hand.

Issues for concern are dished out merrily for contemplation, so that we will forget who is responsible. Capitalism ploughs on, a little richer—yeh, seeming to be less culpable— certainly. That 'our side' gets fifteen minutes to mouth off as the voice of angry people highlights the fact that collectively we are to remain silent and supervised spectators. Rather than this false image of participation, the only thing that it would be positive to vocalise is the recognition that we do not have a voice (and maybe also that we would rather burn down the platform from which we are harangued).

Besides, you cannot buy into, legislate or mandate a multinational to make revolution, the same as you cannot programme people to 'rise up' by throwing images, information or pop videos at them over a television screen.

Act-Up may tell us that Silence Equals Death, but what does that make media exposure? Grave robbing? Necrophilia? Coverage of abuse does not stop it, the same as pictures of the 'hero' stood before the massed tanks in Tiananmen Square didn't stop him getting squashed minutes later. World 'public opinion' does not prevent this—force of arms and a willingness to use

POPULAR MUSIC

When the Blaggers are, through the grace and goodness of EMI, playing on every walkman, when they are splashed across the pages and covers of every music paper, magazine and fanzine, when they are blasting anti-fascism through every radio and delivering the message live on TV, when their slogans echo across every march and rally and when every teenager gets their first grope to the sound of their *unique blend of punk and rap* when the Blaggers are diffused to infinity, when they appear as an infinitely expanding, infinitely fragmenting video relay that encompasses the globe, then we will be rid of fascism?

Underground
P.O. Box 3285 London SW2 3NN

them (business interest or insurrection) does. Wars continue the exploitative peace by other means; hence war will never be stopped by peace marches, appeals to 'public opinion' or televised blood and guts. The media's claim to hold the power to change the existing state of affairs is a shabby self-serving fiction which disguises its interest in maintenance of this status quo. The glut of information is so deadening, the revelation of another outrage or atrocity nowadays leads to little more than bewildered resignation (charities recognise this, they call it 'donor burnout' which occurs when there are so many disasters in such a short space of time that each individual catastrophe loses its power to shock and concern). And that's what they want— inactivity—which is why we never got pictures of the thousands of working class people who fought the Chinese State tanks for hours as they advanced across the city towards the square and why they insisted that all the demonstrators were pacifist students.

Tiananmen Square 1989

Shroud-waiving and hand-wringing concern for distant others keeps us running on the spot in the exploitative treadmill, whirled around so fast we have no time to stop, consider and act upon our own oppressive experience. The media circus selectively exploits both subject and object for its own purposes. All that programmes on famine in Ethiopia (and all the charity commodities spewed out by the media factory to accompany them) do is feed us despair and that keeps both victim and voyeur quiet and law-abiding. They do not show anything that might put the situation in perspective. They do not screen shots of Ethiopian government ministers and relief 'workers' driving around in luxury air-conditioned four wheel drive vehicles.

Television's current emphasis on barbarism in former Yugoslavia is intentional—they are insisting that we as *individuals* are helpless to do anything about it while insisting that *something must be done*. By who? By power of course—with a mandate from us proles. In this way the media creates demand for more state control and intervention into people's lives (with *itself* as arbitrary arbiter). The cry goes up: Save Little Irma, Baby of Bosnia—because she's a child and might have a good working life ahead of her to expoit (unlike the aged who are an encumberance to any 'modern' society), because she's white European, because a lot of Brits have taken holidays in Yugoslavia or because the cameras are there and not in Angola? (Two months on and 500,000 African corpses later, Irma's slow and not very televisible recovery in hospital ends up on the cutting room floor and Angola does get its turn at the top of the hit parade). Disaster pornography depicting poorly children is carefully framed to sell papers, programmes, politicians and world policemen. An ex-PR man is currently putting his feet up in Number Ten.

'Public opinion' is as manipulable a media concept as unemployment figures. This has been understood in Mogadishu where journalists are no longer considered sacred cows syphoning publicity for causes into the "global village". They have become as legitimate a target as the $135-a-day blue-bereted U.S/U.N oppressors.

Information via mass media is worse than useless because so much of it is intended to disorientate us. It is designed for impact—to keep us watching; and mood—for opinion-

The Right to Remain Ignorant

"The citizens of Fairfax ought to be 3½ times more informed than the average American, who has but 35 channels to choose from, and 100 times better off than those primitives still struggling with a single TV station, or none at all. I, however, taped nearly everything that came over the Fairfax system on a single day in 1990, and then spent a year watching it—2,000 hours of programming. As a result, I can testify to a simple, if somewhat baffling, truth: if our goal is to create truly informed citizens and societies, the mere absence of restrictions on information-gathering and transmission is not enough. In fact, there must be ways in which an unmitigated flood of information actually undercuts understanding."

creation useful to corporate interests. As with increased mobility, a surfeit of communication ends up taking us nowhere. I would suggest, for the benefit of collective consciousness, the former Soviet Union's technique of *stopping* the information flow on television when a particularly 'noteworthy' event occurs, presenting viewers with a blank screen and the music of Beethoven. That space might at least demonstrate the futility of looking to the media for annotation, answers, *orders*. The blank screen may be the most potent revolutionary image that could be transmitted. It may be so because of the paradox contained in the observation that we have never been better informed and never more ignorant of the world around us. This is due to the disjunction between *availability of information* and *opportunity to act* on information received. In the controlled environment of the 'information age', we consume argument, debates and opinion in place of activity.

"The interested and informed citizen can congratulate himself on his lofty state of interest and information and neglect to see that he has abstained from decision and action. He takes his secondary contact with the world of political reality as a vicarious performance. He comes to mistake **knowing** about problems of the day for **doing something** about them. His social conscience remains spotlessly clean. He **is** concerned. He **is** informed. And he has all sorts of ideas as to what should be done. But, after he has gotten through his dinner and after he has listened to his favourite programmes and after he has read his second paper of the day, it really is time for bed". Paul Lazarsfeld and Robert Merton

NEWS AGENCY	WORDS PER DAY
AP	17,000,000
UPI	14,000,000
AFP	1,000,000
REUTERS	1,500,000
TASS	4,000,000
TOTAL (1987)	37,500,000

The legendary media falsification of motivation for social change is the so-called Vietnam Syndrome, the claim by the U.S. media that it was their coverage of American exploits in Vietnam that brought about eventual troop withdrawal. The removal of troops from Vietnam did not come about through media exposure; the media merely made the war a symbol of what was problematic to the continued normal functioning of American society. This definition was arrived at under conditions of increasingly frequent explosions of class warfare, ghetto rebellions, campus revolts, counter-cultural upheavals, riots at military establishments (Fort Dix, New Jersey), troop mutinies in Vietnam. Civil war. "Our constitutional system is becoming a shambles and anarchy" declared Senator Kuchal in 1967. He was right and it got worse over the next five years. Returning war veterans took to the rooftops in the 100 city uprisings that followed the murder of Martin Luther King in 1968. GI's in Vietnam were refusing to fight, killing officers who tried to make them—over 1,000 *recorded* attempts to do so between 1969 and 1972. In that latter year one in four U.S. troops across the world had gone AWOL or deserted.

The growing movement for insurrection was defused through its exposure and accompanying media definition of it as a demand to end an *external* war, the intention being to ensure the return to *domestic* social peace once this single measure had been fulfilled (ultimately achieved not only through diversion but through wholesale internal military attack upom members of the Black Panther Party and later the American Indian Movement, and many others). The war was consciously sanitised by reporters: the Mai Lai massacre and the bombardment of Cambodia were ignored until long after they occurred and it was government advisers and the business elite who became disillusioned with the war before the media as it became clear that it was unwinnable and the costs too high. Government disenchantment was *followed* by media criticism of government policy.

"The major reason that the three main TV networks turned down the first option on the 'Pentagon Papers' [exposing American military strategies in Vietnam] was that their parent companies were all heavily involved in servicing the war effort."

<div align="right">Richard Bunce, TV in the Corporate Interest</div>

JOIN THE WINNING TEAM!

AS PART OF OUR GENERAL PROGRAM OF INTERNATIONAL GOODWILL, WE BRING YOU

BRAVE NEW OPPORTUNITIES

FOR MARKETING IN EASTERN EUROPE - 200 MILLION PEOPLE ARE JUST *DYING* FOR IT

"Running a business in the leisure industry is no different from any other—the same principles of management must and do apply. We have to examine market potential, identify growth areas, set up a sound and imaginative marketing plan to exploit the situation."

<div align="right">John Reed, ex-Managing Director of EMI</div>

"There's the hole...

Go on—
put your head in it

That's it: pack the
loose earth around

Relaxed?

OK then...

...here is the news"

TV commercials wash whiter!

The majority of television commercials take the form of religious parables: they put forward a concept of original sin, intimations of a way to redemption and a vision of Heaven.

Consider The Parable of the Ring Around The Collar: a married couple are in a restaurant, enjoying each other's company and generally having a wonderful time. A waitress approaches their table, notices that the man has a dirty ring around his collar, stares at it boldly, sneers with cold contempt, and announces to all within hearing the nature of his transgression. The man is humiliated and glares at his wife with scorn. She, in turn, assumes an expression of self-loathing mixed with a touch of self-pity.

The parable continues by showing the wife at home using a detergent that never fails to liquidate dirt around the collars of men's shirts. She proudly shows her husband what she is doing and he forgives her with an adoring smile. Finally, we are shown the couple in a restaurant once again, but this time they are free of the waitress's probing eyes and bitter social chastisement.

The Parable is short because it is expensive to preach on television (the cost of making an average 30 second commercial is £120,000; to screen it at peak viewing time once only costs £220,000). In addition, the attention span of the congregation is not long and easily susceptible to distraction.

In TV commercial parables the root cause of evil is Technological Innocence, a failure to know the particulars of the beneficent accomplishments of industrial progress. This is the primary source of unhappiness, humiliation and discord in life. The consequences may strike at any time, without warning and with the full force of their disintegrating action. To attempt to live without technological sophistication is at all times dangerous, since the evidence of one's naiveté is painfully visible to the vigilant.

There is, though, a road to redemption.

But you must be open to advice or social criticism from those who are more enlightened. One must also be willing to act on the advice that is given. As in traditional Christian theology, it is not sufficient to hear the gospel or even preach it. One's understanding must be expressed in good works—that is

action

In The Parable of The Person With Rotten Breath, we are shown a woman who, ignorant of the technological solution to her unattractiveness, is enlightened by a supportive roommate. The woman takes the advice without delay, with results that are shown in the last five seconds: a honeymoon in Hawaii. In The Parable of The Stupid Investor, we are shown a man who knows not how to make his money make money. Upon enlightenment he acts swiftly, and, at the end, is rewarded with a car, or a trip to Hawaii...

The ending is the moral of the story: if one will act in such a way, this will be the reward. But in being shown the result, we are also shown an image of Heaven—accessible and delicious; a Heaven that is here, now, on Earth, and quite often in Hawaii.

Ecstasy is a key concept here, for commercial parables depict the varieties of ecstasy in as much detail as you will find in any body of religious literature. At the conclusion of The Parable of the Spotted Glassware, a husband and wife assume such ecstatic countenances as can only be described by the word beatification, pure and serene. And where ecstasy is, so is heaven. Heaven, in brief, is any place where you have joined your soul with the Deity—the Deity, of course, being

Technology

from a Neil Postman article

55

NINJA TURTLE PIZZAS BY ANY MEANS NECESSARY

"It was to advertise the museum that Barnum invented his famous 'brick man'. He hired a stout hearty-looking man for $1.50 a day and handed him five bricks. He instructed the man to lay one brick at each of four points around the museum. The man kept the fifth brick in his hand and marched rapidly from one brick to another, exchanging the one in his hand for the one on the street. At the end of every hour, the brick man entered the museum, spent fifteen minutes solemnly surveying all the halls, then left, and resumed his work. Each time, a dozen or more persons would buy tickets and follow him into the museum hoping to learn the purpose of his movements. **Their entrance fees more than paid the brick man's wages.**"

Leftist programming or rightist, television product remains programming. Its target: conform like a good 'un, consume products, adopt lifestyles. In contrast to a concentrated totalitarianism, domination is achieved, not through enforced methods of conformity to one leader and one singular ideology, but by the multiplication of opinion on void and virtual political issues and the 'voluntary' involvement and participation of every spectator in a diverse choice of concerns, identifications and roles. Social control is maintained in both systems, the general level of abundance determines the path taken to reach it.

"The means of mass transportation and communication, the commodities of lodging, food, and clothing, the irresistible output of the entertainment and information industry carry with them prescribed attitudes and habits, certain intellectual and emotional reactions which bind the consumers more or less pleasantly to the producers and, through the latter, to the whole. The productive apparatus and the goods and services which it produces 'sell' or impose the social system as a whole." Herbert Marcuse, One Dimensional Man

It takes real teamwork to create a shopping revolution

Dreams only become a reality through hard work.
A dream the size of the MetroCentre takes more than
just hard work to materialise - it demands real teamwork

HERE IS THE WINNING TEAM:-
1. Cameron Hall Developments Ltd 2. Rush & Tompkins 3. Dow Mac
4. ANMAC Limited 5. Bede Engineering 6. Bolton Brady Limited

The posing of irrelevant questions, the raising of fatuous dilemmas, the false choice of alienated lifestyles is wrapping paper for the products of consumption. It is participation imprisoned within the occupied zone of appearance, limited to the activity of choosing between buying, not buying and buying something else. Television promotes the entire capitalist machine by representing the very objectives of that economy. The apparent ability to produce and successfully market a never-ending supply of gadgetry renders capitalism immune to criticism. It is successful precisely because it is in place and continues to grind along (albeit in fits and starts). Strikes or riots under these conditions then become a disruption of our allotted routines and the vital business of business as usual.

We 'live' and some are happy to die—or at least watch others die—for their own continued exploitation. The promised carrot of abundance is backed up by the threatened stick of scarcity, because the satisfaction of basic needs will always be the best safeguard of alienation (even though this is a society where resources are potentially *over*abundant). Media coverage of the downtrodden, the deprived and the depraved, serves to bolster the belief in everyone's head that at least each and every one of us is a little better off than someone else. It's a society-sized delusion, fooling ourselves to be happy that we're not unhappier.

Engaging substitutes for real life are all important under these conditions. An engrossed passivity is the benchmark of the new regime as lifestyle advertising largely replaces promotion of a product's actual utility. The media will cover anything that can be turned into a commodity and sold on this basis. Time Warner owns Lorimar, the largest U.S. television production company, makers of Dallas and the film Malcolm X, the copyright on Superman and the contract on Tracey 'Talkin'Bout A Revolution' Chapman. The more exotic the artiste or subject matter the better for corporate marketing—these minority niches particularly appeal to the jaded '90s white middle class, a class which has always sneered then quietly lapped up both upper class and working class culture to hide its own lack of any culture at all. The spectacle responds to their disappointment with routine lowest-common-denominator uniformity by diversifying itself into novelty roles and integrated dissatisfactions tailor-made for specific social groups. Recuperation (absorption of all spontaneous movement to live free of control) is a smothering pillow so much easier accepted than the slash and burn of cultural fascism. The New Men who pay to take themselves and their 'partners' on work weekends at organic farms are no more nor less alienated than the rest of us. They are the perfect dupes of ad-men who play on their cynical and illusory superiority over 'the herd'. Happy happy holiday in Cambodia.

Honolulu's Eco-Crusader

It only took a close-up look at L.A. smog to turn Hawaii's top advertising executive, Susanne Sims, into an environmental crusader. On a business flight out of L.A., Sims was "shaken with the severity of pollution", shedding tears as she stared out the window at the charcoal sky. She's now putting her corporate knowledge to work at the forefront of Hawaii's environmental movement—running Honolulu's *Eco-logic* recycling centre. Says Sims, "We have to make the environment as exciting as Calvin Klein jeans and Poison perfume."

> "If everyone is represented, as image, within the media spectacle, then nobody can be said to be outside or excluded. Capital can present itself as catering for all, at the level of appearance, while in social reality the conditions which perpetuate oppression continue. The demands for representation are far more easily met and incorporated into capital than demands for an end to the conditions it produces."
> Douglas Spencer

Repression of all dissatisfaction is fatal. Even the most hostile action can be made to reproduce alienation—the image factory now subverts its own billboards even before we can get at them and screens programmes that ridicule its own politicians. The economy of the market place harnesses to its own purposes even those militantly opposed to it. Ideas can make money just as effectively as things: Malcolm X is good for the T-shirt business, Maoism in its day generated a new fashion in headwear; so all culture, even the most subversive, may be good for business, when deprived of its critical value in being reduced to the commodity for the self-reproduction of capital. The naiveté of Malcolm's wife Betty Shabazz in objecting to Malcolm

Mandela is booed as townships erupt

SOUTH Africa exploded in violence and looting yesterday as at least a million blacks took to the streets to protest at the murder of Mr Chris Hani, Communist Party secretary.
Unofficial reports put the number

IRRITABLE BOWEL SYNDROME?

If you suffer bowel problems such as constipation, diarrhoea, stomach cramps, abdominal

should eat to restore regular habits. The book covers actual case histories of men and women

a police station. Two whites were attacked and killed near a beach in the quasi-independent homeland of Transkei. A third was badly wounded. Police urged travellers to

X crisps is astounding—if we can wear Black Power, why can't we eat it? The chickens have indeed come home again to roost; after all, it was Malcolm who summed up the media as: "They hold you in check through this science of imagery". The credits are rolling, not for Malcolm Little but for the systems that assassinated him. Pass the popcorn, sucker.

In terms of mystification, Spike Lee is doing a grander job for the commodity spectacle than the best minds of the PR world could. Rebellion has been estranged from its original estrangement. The rebels are now employed as the side-show, permitted at the level of spectatorship to allow the serious business of exploitation to continue, undistracted by too much popular interest. Six months on, of course, it's "Malcolm Who?" as his memory is replaced by the next fashion frenzy and subsides into the shrieking nothingness of the latest, the greatest and the immediately forgettable trinkets of banality.

Some activists see that opportunity to influence the production of ideas is unequally distributed, and therefore agitate for greater access—yeh, the media's full of shit, they say, so let's fill it with some of our own 'sound' shit. But who gives a XXXX for Malcolm now? The pyramid of inequality is entrenched, precisely through the technological weapons that ensure it stays that way.

> "Had we produced something truly radical then there is no way it would have been screened on public television. There are government restrictions, and all kind of limitations imposed by big corporations that are shaping what you can see. Our aim was to home into that small margin that lies between bringing up radical statements and to be allowed to voice them."
>
> Paper Tiger TV (U.S.)

There may be cracks in the monolith to be forced wider, but to believe that the cultural sphere is in some way freer or more 'democratic' than any other capitalist industry is a misunderstanding of its essential role in the maintenance of class society. The New York Foundation For The Arts inadvertantly explained the cultural establishment's relation to 'art' and artists in an advert they put in the radical film and video journal *Felix:*

> "Many of us paint and dance and sing or play the guitar. Others of us restore cars, do needlepoint and cook wonderful dinners. But there are real differences in the creative work we do and the art produced by an artist. The important one lies in the intent of the process...they long to reach an audience at the deepest levels of meaning with their work."

'Art' serves power as separation from life when produced by specialists and—it follows necessarily—consumed by an uncreative mass. Verbal and physical expression of how we live is repositioned in the role determined by the spectacle and made to function for passive identification. It is the new prison for the highly subversive forces of individual creation. If paints, brushes and canvas (nowadays it's camcorders) were handed out to everyone who wanted them, suggested situationist Vaniegem, then the system might have a hope of endowing people with the consciousness of the artist, that is: the consciousness of someone

1 A group of situationist revolutionaries has invaded the television centre to disrupt normal T.V. viewing, attack the commodity and media spectacles and demand social revolution. Can you help them find the news room?...

start here →

who makes a profession of displaying their creativity in the museums and shopwindows of culture. The popularity of such a culture is a perfect index of Power's success. Certainly the situationists themselves were no less likely to become victims of re-appropriation by the cultural establishment. Peter Suchin, reviewing in Here and Now #9 the 1989 Situationist International exhibition at the ICA in London, notes that when a demonstrator, who was handing out leaflets attacking the institutionalisation of the SI, ran out of leaflets outside the event, gallery representatives rushed off and photocopied some more for him.

The 'right' to expression, as with the 'right to know' means only so much in virtual media reality. The conversion of communication between human beings into a commodity is the political economy of the active sender and the passive consumer/receiver. The issue is not for a more 'democratic' broadcast media, giving positive discrimination to whatever minority flavour you favour, but to create our own autonomous means of communication.

WE HURT NOBODY

BIGGER ARTS GRANTS LONGER CHAINS

"Imagine a football game. The players are on the field going about the business of football. Their behaviour is full of purpose with shared rules and conventions governing the unpredictable immediacy of the run of play. The spectators, for whom, all this energy is expended, are absorbed in watching. But on the sideline, player number twelve wants to get on to the pitch to take part, and to be seen by the spectators. If he leaps about, gesticulating wildly, he might be noticed as a distraction and an amusement, but that won't get him on. To succeed he needs to be recognised as a bona fide player. His 'representative', the manager or coach, must go through an established routine to catch the referee's eye. And finally, some other player has to be displaced from the field to make room for him. Only then, if he's lucky, will he gain the attention of the spectators."

All forms of culture either contribute to social transformation or prop up existing power relations. Those who choose to work in electronic broadcast media are working within a system highly structured toward keeping tight control over media images. Sponsorship of 'independent' video is an insignificant part of a business whose real interests lie a vast distance from some kind of 'people's TV'. Current developments in the industry are moving in quite the opposite direction. Community access video workshops and even some art school film and video is being defunded. The newest allocations of grants are for vocational training for the televison and film industry with companies such as Skillset who were grant-aided to begin "accrediting courses in nitty-gritty skills". John Woodward, chief executive of PACT, the independent producers' organisation assures us this is taxpayers' money well spent in the service of capital: "This is about training, not charity. It is about keeping labour costs down, about keeping British production effective". Lacking the ability for direct capitalist exchange, independent producers are almost totally dependent on grants from others, to be dispensed or witheld as economy dictates, and funding by private as well as government agencies is currently shrinking fast, while the cost of state-of-the-art broadcast videotape production and post-production equipment has rocketed.

Funding allocations in Britain are a reflection of increasing monopolisation of televison on a global level. "We stand," media tycoon Rupert Murdoch says, "at the dawn of a new age of communication". The competition* of the market place is, of course, its motor. The lifting of state broadcasting monopolies across Europe due to deregulation has passed control of previously publicly-owned channels to the largest wielders of private property—the media multinationals—whose resources now outweigh the gross national product of many of the countries they operate in. Twenty years after deregulation in Italy (a response to mass illegal transmission) that country's 400-odd local TV stations mostly serve U.S. and multinational programming. Similarly, new commercial channels make more money if they buy cheap all-

* What *is* economic competition under capitalism? Does the entrepreneurial battle for our hearts and minds and the democratic spirit of free enterprise ensure delivery of a *diverse* range of the *best* product that could possibly be offered? Or is it one big corporate and bureaucratic link-up at the top where a miniscule number aid and abet each other to spew out for consumption the same tired old crap, produced and distributed at the cheapest rate and sold for maximum profit?

The BBC deals news with ABC in the States; ABC sells news and magazine shows to Murdoch's Sky News, a BBC 'rival'. Murdoch now controls Star TV—the biggest satellite system in Asia—which carries BBC TV World Service programmes and CNN live programmes. He's also started working with Telecom/Cellnet to create "the digital super-highways of the future" (after-dinner speech 1.9.93). This 'global village' is indeed a very small world; at least for businessmen.

Rupert Murdoch's TV Dinner

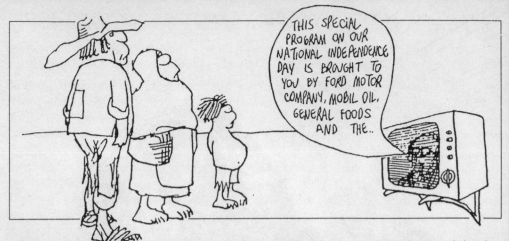

purpose U.S. shows and sell airtime to advertisers, rather than commissioning or originating their own programmes (annual television advertising revenue in Europe has gone from $8 billion to $18 billion in the last five years).

The long-defended barriers to protect British broadcasting from outside intrusion are being dismantled. This isolationism is a throwback to the days of Imperial power and its destruction in the face of cultural globalisation is inevitable. It has meant, though, that British media belts are being tightenend like never before. The BBC is slicing up its entrenched departments with the Producer Choice strategy, while the commercial stations are shedding workers as if there's no tomorrow. HTV dumped 150 workers last year and put a pay freeze on those remaining. Meanwhile, bosses of this 'struggling Channel 3 broadcaster' (Independent 22.5.93) awarded two of its directors over £205,000 for moving house on top of £125,458 salary each and pension payments of £20,991. "I regard these as perfectly normal amounts for relocation of key executives" says HTV chairman Louis Sherwood chairman. The resources are certainly there. So is capitalism.

More than ever before, current policy in Britain is allowing for reward for a select few in the funding game—displacement, the wilderness for the rest. One independent producer's gain is another's loss. This fosters a highly competitive individualism, which makes difficult creation of any collective demands for access for themselves, still less any wider circle of potential users. Independent image producers, even so, maintain that if any openings allow radicals to get work made, if work gets distributed and if there is more visibility—then that must be beneficial. But is the door opened just enough to let a few art-school educated exotics squeeze through? And why? Because what could be more talked about than the new style of opposition—a revolution in revolutionaries! The bourgeoisie enjoys images of revolt, it creates subject matter for their magazine culture. It is a great diverter of collective struggles to change human life, turning instead towards the cultivation of individualized efforts to attain infamy, wealth, acceptance or greater margins of movement within the power structure.

"All these places like Video Umbrella seem to be set up to help ex-St Martin's students get jobs with Channel 4. There's loads of people who are really active, all signing on, all doing stuff off their own backs, not an arts grant between them. Then on the other side there's others who are precious Arts Council dandies who produce shit rapped in arty wordspeak and make a living off it."

Ade L. Vice

"THAT'S NOT TELEVISION, THAT'S CHANNEL 40!"

"There can be no successful dictatorship without the establishment of procedures through which people are invited or forced to speak" Bernard-Henri Levy, Barbarism With A Human Face

Is capitalism destined to control *all* image output of the media and entertainment industries? Couldn't some kind of 'community' television lower economic barriers to expression, return power to its receivers and provide some margin of independence for radical activists within it? Could 'open access' channels provide an inexpensive means for distribution of material that cannot otherwise get shown?

Today over 60% of U.S. homes get their television by cable—the cable operator for a given area works under a negotiated franchise that can require that they provide the equipment and facilities necessary for programme production by local people on at least one specially designated public access channel. Local origination programming was mandated by the Federal Communications Commission in 1972 and though overturned by the Supreme Court in 1979, it has since been reaffirmed by the U.S. Congress which has authorised municipalities to demand access channels if the local population so desires.

The ability to produce 'amateur' TV was made possible in the seventies when low gauge video equipment became cheap enough and easy enough for use by non-professionals. The invention and sale, at a reasonable price, of the 'stand alone time base corrector' enabled stabilisation of half-inch low-gauge video signals, making output transmission more reliable and hence watchable.

Technological advances alone do not account for promotion of access facilities; a political decision, by the owners and controllers of capital, brought about its provision. The development in the U.S. of the "video soap box" was a response to the widespread uprisings of the late sixties and early seventies. The Kerner Commission on Civil Disorders reported that riots were caused by minorities having no opportunity to speak for themselves through the media. The Presidential Task Force on Communication Policy 1968 concluded that telecommunications could play "a fundamental role in achieving understanding and harmonising conflict among modern societies dominated by diversity, mobility and the claims of social justice". In other words, reduce social tension without changing the social order.

What interest might government or corporations have in funding such channels in Britain? Six community cable channels *were* set up in Britain in the seventies on the lines of U.S. public access stations along with funding for facilitators' wages. Channel 40, in Milton Keynes, was funded by the Development Corporation in charge of constructing this new town development. It was government funding—typical of its time, and heresy in today's political climate—intended to foster 'community' creation. The other five stations were paid for and owned by private companies. This was before the advent of direct satellite communications to the individual home, when there was great interest in extending cable services in Britain into the area of 'Pay TV'. Pay TV is the sale of new films, old movies and exclusive sports coverage on a pay-as-you-receive channel by channel basis through which mega-profits are reaped. The British projects were commercial public relations exercises to demonstrate to the Conservative government of the day that the operators were capable of 'responsible' management of this kind of service. They were also convenient research and development opportunities for the companies to test their hardware: instead of costly and directly-employed

technicians, the promoters got community-oriented workers, whose enthusiasm they could exploit, to run them on the cheap—and until the workers wised up—with a non-unionised workforce.

When Labour returned to power in 1974 and reinstated the Annan Committee, who made it known that Pay TV would *not* be one of their recommendations for the future of broadcasting, the cable companies promptly closed down the projects in Wellingborough, Sheffield, Greenwich and Bristol. As Rediffusion put it when pulling the plug on Bristol Channel TV:

> "The local experiments cannot extend their scope **into other services** which, commercially, might have justified continuing"*

The remaining commercial project, Swindon Viewpoint, was little different though it survived for longer. It was set up by EMI, sold off for a £1 nominal fee when its utility was considered redundant and struggled on with money from public lotteries.

Despite shaky capitalist foundations, workers at the local stations had the best progressive intentions. They were breaking new ground in broadcasting, at the forefront, they believed, of new ways of seeing and new mediums of communication. It was a lot more than funding problems though that dashed their hopes. Their facilities got used by far fewer people than originally anticipated, and those who did already had easy access to the media:

> "A significant proportion of the programme initiators were middle class men despite the fact that the great majority of the population in the cabled areas were working class."

The democratic possibilities of a media are only as democratic as the society they exist in. Where inequality exists, and where some groups have far more resources than others, access to television will favour these privileged groups. Established institutions were the greatest users; at Swindon viewpoint, for example, the Police had a regular slot every Friday evening. Such organisations were already well versed in putting their views across, some having paid PR personnel. This was certainly the case in Milton Keynes where a regular programme maker was the Development Corporation (central government's appointed quango of planners and developers, the same kind of authority as created the Isle of Dogs Enterprise Zone and Canary Wharf—elected by no one, selected by internal boss class nepotism). The MKDC employed two people to put together a weekly 'magazine' format video of all the good things it was doing.

Project workers found that "community" access is as false a proposition as consensus politics. The notion of 'community' assumes an identity of interest based on residence, a kind of local nationalism/chauvinism, which denies that fundamental conflicts of interest exist between sectors of that micro-society. For what is the community, but only global class confict in miniature. So by promoting community 'togetherness':

> "It can be argued that Viewpoint and Channel 40 in reality—despite their liberal posturings—have a reinforcing effect on maintaining local status quo. As national TV reflects the national status quo, so, one can maintain, on a smaller scale, local TV is serving exactly the same function."

It was a little hazy what access to televison production for the community was actually supposed to achieve. Undoubtedly the bottom line for the backers of the projects was profit. For some of the workers involved it was the belief that if you teach someone how to use a video

*Quotations in this section from "Local Television: Piped Dreams?"
by Andrew Bibby and Cathy Denford Redwing Press ISBN 0-906625-01-7. Recommended.

camera, they will never watch television in the same way again. Gaining skills in the use of a medium, they suggested, gives users a means of communicating their views and a language in which they can analyse the appearance of what is around them. It can make you more critical of other media representations (though whether your own representations within that medium can move receivers of your messages onto that ground was never discussed). The gaining of media awareness on the part of local users who got involved was not so apparent:

"Most have the same attitude as the typical home movie-maker. The medium is discounted, treated merely as a mechanical recording process which in no way affects the subject matter of the finished programme. So the characteristics and limitations of the medium are hardly recognised, let alone explored or extended. The resulting programme items therefore have a peculiar effect on the viewer. **They certainly don't look like 'television' as everyone knows it, but they don't look like anything else either**...

Programme makers spend little time considering why they should make a programme, or who they are attempting to reach. When asked, people tend to say vaguely that they think the general public would find their subject interesting or useful, without much consideration being given to **what** exactly is useful, to **whom** and **why**... The most common motive is the general desire to gain publicity for their particular cause or organisation."

It was found at both Swindon Viewpoint and Channel 40 that as the novelty of exploring video techniques wore off, many community members had little interest in becoming regular video producers. Making video takes a lot of time and many just cannot afford to get involved, even if they wanted to. Helping individual and community organisations make programmes takes months and months of phone calls, evening meetings and training sessions to make a ten minute piece. The station workers—who were meant to be only 'facilitators'—had to fill increasing amounts of the available transmission time each week themselves, which left them less time to work with community groups. The apparent solution (a cable network) to the generalised problem of how to distribute low-gauge video work became itself the new restraint. The pressure to produce a regular supply of material to fill the available airtime, as with broadcast television, discouraged experimentation and instead made for simpler (and so longer) programmes for transmisssion. Both stations initially set out to transmit 4-6 hours of original programming weekly; they ended up putting out between 1 and 2 hours.

The coal miner conflict has finally been resolved and work will probably resume again tomorrow. It is perhaps the feeling of having participated in the debate that explains the almost complete calm that has reigned continuously throughout the last thirty-four days in the miners' quarters and in the pitheads. In any case, television and transistor radios helped maintain this direct and permanent contact between the miners and their representatives. However, the same media also compelled everyone to go home at the decisive hours during which, on the contrary, only yesterday everyone would go out to meet at the union headquarters. *Le Monde*, 5-4-63.

Written material on these British experiments makes for sobering reading. The high hopes of the late sixties were dashed to disillusion when put into practice. Project workers who became critical of what they were actually employed to do, questioned:

"Why should we want to make people more familiar with TV? For what purpose are we trying to 'demystify' television? Why television? Couldn't the necessary expenditure be put to use in other more socially useful ways?"

THE POLITICIANS' MIRROR
(by the Lancaster Bomber)

The media is the politicians' mirror, developed in the politicians' and corporate financiers' interest. It exists to sell a product. Politicians and products alike thrive on being seen on the screen, they crave its validation. As a mirror, it is but an image, a self-contained world, flat, insubstantial and *brittle as glass*. The media sweeps everything before itself, absorbing it, simulating it. The future is one of virtual reality, a world where people are having unbelievably vivid and beguiling experiences, but none of it is real. The media forges a version of a brave new world which is already completely forged, a world of virtual economic recovery and super-soaraway market confidence trickery.

Before, people had their own thoughts, they made their own music, told their own stories. Before we saw things for ourselves. Now we see them through the distortion of the electronic lens. Events can only be valid with reference to the power structure controlling the media. If it isn't reported, it didn't happen. The phrase "the oxygen of publicity" (an expression that refers to coverage to be denied to 'terrorists') contains the implication: the media machine will determine what intiatives will survive, and what initiatives will suffocate.

SELLING THE PRODUCT

The relationship of the individual to the media is manifest in the advertisement. Pictures are shown of products, and associations are set up between the product and a promised lifestyle which the viewer will find attractive. Through repetition, the product is established in the mind of the consumer. During the next visit to the supermarket, the customer picks the product off the shelf. Sales figures, audience surveys and advertising budgets are compared and more

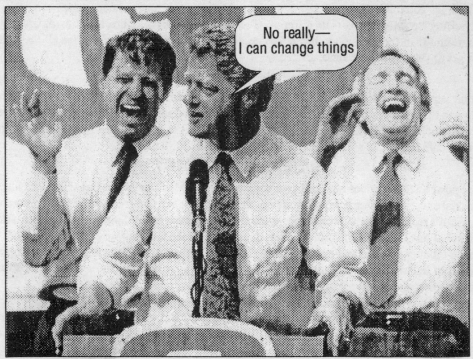

THE LOOP OF ILLUSION
Vince is, in fact, no different from the performing seal, or the actuator in a servo-mechanism. The only thing that keeps him pressing the button is his sense of reward—the idea that the things he sees, the things he buys and consumes are good, and that his act of choosing is important. In fact the things on offer and choices he makes in the supermarket have all been fixed before and determined by the way the system has been set up

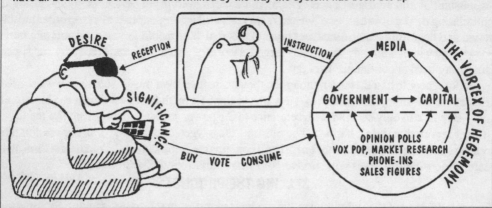

adverts are broadcast, while the television company produces more of the same programmes to wrap round them. And so it goes on.

The input which the individual has is nothing. The choices are already defined. All the supermarkets are essentially the same, all the products the same, the shelves and the trolleys the same. The individual's energy is dissipated through each consumer transaction.

Selling a political party is no different. The choices at the ballot box are considerably less important than the decision to buy a particular brand of coffee—we buy coffee all the time; we get to vote around 12 times a lifetime.

CORNERING THE MARKET

If the imposed, one-sided world was openly presented to us as such, few would accept it. The illusion of consent—an artifical reciprocity—has to be generated. Vox pops, phone-ins and opinion polls, all this media *noise* is a necessary part of the product, just like the cellophane on the coffee jar.

THERE IS NO RECIPROCITY

The power structure does not need your support . Prime Minister's Question Time, the latest scandal or crisis or U-turn in policy are not there for your *active* agreement or disagreement. It doesn't really matter if John Major is unpopular (or how much Spitting Image take side-swipes at him) because changing leaders does not alter the fact that we are still governed. It doesn't matter whether you enjoy or dislike DisneyWorld, none of it matters, just so long as you keep buying the coffee, just so long as you keep wheeling the trolley down the same supermarket aisles and paying at the checkout.

What use is 'public opinion', if everybody remains in their armchairs? Can public opinion be said to *exist* at all, if it never translates into *action*? It doesn't matter how unreal, how unsupported the power structure is. So long as you go on allowing it to define reality for you, you will never defeat it.

ENTER THE REFORMIST

The reformist is a reactionary, reacting to the system or, particularly, to some aspect of the system. Reformist campaigns are limited in scope because they don't seek to abolish government, merely to modify it. The reformist operates by methods such as petitions, holding meetings, demonstrations, standing candidates in elections, and getting others beaten up by policemen. A three-tier pirate hierarchy is the means to work this strategy: a mass of uncommitted supporters at the bottom (the petition signers, voters); a smaller group of activists in the middle (the footsloggers who attend the meetings, demonstrations and hand out the propaganda); and at the top the professional campaigners, leaflet writers and chairpersons (the image builders).

PLAYING THE NUMBERS GAME

"If we can convince enough people to vote for us..." "If we can get enough people to sign the petition..."

Why is one opinion worth less than ten thousand opinions?

When the campaign plays the numbers game, it assumes that public opinion *counts* and by inference—as it can only be judged numerically—the individuals who make up this numbered mass *do not*.

The people who determine the course of the campaign use numbers to persuade the government to alter a particular policy. Such a movement poses no threat to the power structure itself, because it *still* acknowledges the legitimacy of that power structure to govern and draws its own legitimacy from the 'democratic' headcounting spectacle of that power structure. The government, for its part, knows that the anger and activity organised in this way will soon dissipate.

A similar, more openly vanguardist way of working would be to capture the media itself, using the numbers behind the leadership group to put pressure on the bureaucratic power structure of the media. This is a similar approach to a shareholders' rebellion at a company AGM. Mary Whitehouse's National Viewers and Listeners Association is an example of this. Instead of asking for a different government, this movement asks for a different media.

MOVING THE GOAL POSTS

The State plays a *waiting game* against those who oppose its actions because it holds all the cards (in a strong and ruthless hand, if necessary) in a drama of its own design. It is in a position to refuse to move, leaving the reformist nothing to *react* to. It is at this point, where the numbers stabilise, that the movement starts to stagnate—because recruitment has been its only *active* process. It is then that the protest leaders declare, "The time has come to take a short cut—apply the leverage of the publicity machine itself on behalf of our cause". At once, a gap is drawn between the body of the movement, if it still exists, and the figureheads. The leadership gets drawn into the media circus; the figureheads become the identity of the movement.

The figureheads have to match themselves to the aims of the media, because the media is not there to present your case but to ensure that you pose no threat to the status quo. That is the condition of entry, take it or leave it. Movements which don't accept the framework or don't play by the rules are denied the oxygen of publicity. 'The oxygen of publicity'—on come the performing seals for thirty seconds of air time, as the rest of us relax into our armchairs.

ALL POWER TO THE WORKERS' BOUNCY CASTLES

Leadership has defined itself in relation to the power game and media circus. The media game becomes an end in itself rather than the overturning of the situation we were initially opposing. Leadership's only function now can be collection of more attention *for itself*. Leadership cynically shatters its own myth of mass 'public opinion'.

Instead of the movement turning over the situation, the media turns over the movement as the leaders alienate their duped supporters. Leadership is in the saddle now and rides its conquered followers. The celebrities accept this, and if they are successful deliver to the cameramen a series of nicely turned out publicity stunts, for their own personal aggrandisement and future careers. The media image is something that isn't real; participants are thus adopting a role, acting, pretenders to what they wish to be—the new class of exploiters. The movement itself has become emaciated, bankrupt and useful only as foot-soldiers.

Celebrities actually support the media machine, because they help maintain the illusion of media-defined dissent.

Seeking after the validation of the power structure itself for our opposition to it is a fundamentally incoherent approach

If the power structure thought our interests were valid, it would never have acted against us in the first place, and we would not need to protest. The concesssions that it does publicly concede are made because they are of little value and can be taken away again if necessary.

No other policing is getting such a good reception from viewers.

We don't need to watch television or work with television— our lives and potential are a thousand times more fascinating. Our first impulse should be to obstruct the media; by liasing with the going scheme of affairs, we consent to the continuation of precisely what we ought to be against.

Dissent that is manufactured for media consumption is no dissent at all. Instead of accepting the false agenda posed by the democratic DisneyWorld, we have to develop our own. Instead of allowing ourselves to be duped into accepting the imposed framework, we have to destroy it, rupture the dominant reality and make the media irrelevant. Smash the politicians' mirror.

MANUFACTURING DISSENT

"Kidnapped newspaper editor Reg Murphy described afterwards how the first thing his abductors did was turn on their TV set to see if they had made the evening news."

Ordinary people who want publicity for their actions (you can forget their ideas) find that TV's definitions of 'newsworthiness' determines the nature of their activity and distorts the original intentions in taking political action. People are *forced* into ridiculous stunts to get their message across. Look at it this way: if the media had been interested in the rights and wrongs of convicting bank robber George Davis, whose demand for freedom got painted up in every working class area in England, there would have been no need for his supporters to go and dig up Headingley cricket pitch before a Test Match (to get the media attention that would embarrass the government who would lean on the judges to assemble another court to ask the question: was he guilty?)

From CND to Class War, protest and demonstration is being organised primarily for media attention, getting the numbers, getting on the news. Not much thought is put into *who* this coverage is actually meant to benefit, and *how*. A group's fascination for publicity can end up in doing things simply in order to get it, while liasing with the media—to get them to come and look at you—can take up so much time you can't get anything else done. It is a short step from this to a group mutating into a bureaucracy, *the necessary form for operation of a media strategy.* For who's the best person to go and do an interview—the best talker, the most photogenic, the person who did it last time? It's all too easy for the comrade with personal contacts to the media, a way with oratory and previous knowledge to make themselves indispensible. TV people lap it up, it creates individual stars of previously collective movements and makes their job of coverage so much easier. Our will to live is cut down to a sound-bite; our collective strength is reduced to a single figurehead who's easily compromised or rubbished (such as Arthur Scargill). The flip side of this strategy of using and being used by the media is that other activists can easily be seen as jeopardising the precious media image. All at once the extremists are out. No more anarchists at the Green Party conference—"We have the *image* of the movement to think of, people won't want to join a movement of extremists". Who says? Maybe people don't want to join a movement of sharp-suited yuppie clones either (except other sharp-suited yuppie clones).

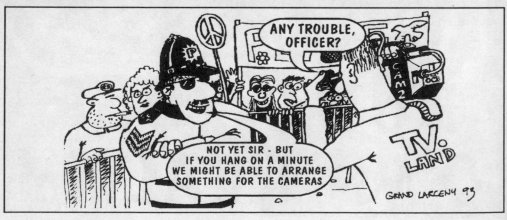

SHOP 'EM

What kind of activity can be expected from media-oriented campaigners desperate to attain 'the right image'? Will they disavow their most effective tactics in the belief of some wider mass support strategy? Before Earth First's Timbmet action (occupation of a timber yard dealing in tropical hardwoods), anarchists involved in organising for the demonstration were taken aside and told that if any of 'their mob' were thinking of doing anything out of line with the organisers' carefully prepared media stunt there would be no hesitation in handing them over to the police. Earth First UK is but the latest movement to have lost itself down the media sewer; all that remains of interest is to see which of the self-appointed leaders lands the salaried position in the burgeoning British ecobureaucracy.

The media's fear of any threat to its self-importance is contagious. Any movement that organises in its shadow will catch the disease—the All Britain Anti-Poll Tax Federation promises to weed out the rioters amongst its ranks, the National Union of Journalists recoils publicly with affected outrage at those members who went trashing T.N.T lorries at Wapping (and, significantly, an ITN news van—3/5/86).

Publicity *can* make people aware of a campaign and enable them to join in; it can bring into the open something the authorities want to keep quiet. It can also be useless, or even harmful. If an event is not covered, did it 'happen'? Struggles judged and designed around media exposure affects the importance people attach to an issue and how involved they might become in it and for how long. How do *you* feel watching demonstrations, even riots, on TV? Have *you* ever resolved to take action due to something you've seen on TV? Mediation increases the distance of the audience from the protesters; we might possibly feel a little sympathy, but *em*pathy—never. It is a few speaking to the many, actors playing for the edification of an audience. Appeals to the mass never threatens the basic structure of mass society itself. We attack the spectacle with the same weapon that imprints the order of passivity on our daily lives.

"The information which reflects or diffuses an event is already a degraded form of that event. The role of the media in May 1968 is a case in point. The coverage given to the student revolt gave rise to the general strike, but the latter turned out to be precisely a neutralising black box, an antidote to the initial virulence of the movement. The publicity itself was the death trap. One must be wary of the attempt to universalise strategies through the dissemination of information, suspicious of all-out campaigns for a solidarity which is both electronic and fashionable."

Jean Baudrillard

Trying to work in an environment that can never be our own, attempting to reach out to some ill-defined 'others' via the media, we end up fighting alienation with alienated forms. But the character of revolutionary movement is not exciting enough, not able to match the artificial, the contrived, the excitement of cop car chases. The stunt must become ever more ridiculous. Do

Monday 11 May

Watch the telly!

☞ BBC2 7.30 pm

For the first time on television:
- Timber stolen from the reserves of tribal peoples is traced back to British importers
- It is revealed that some of the biggest companies in Britain are trading in timber whose illegal extraction threatens to exterminate indigenous peoples
- How the people of the more isolated reserves have been murdered

The British timber industry is trading in human lives!

Earth First! Tropical Timber Day of 'Action' leaflet 1991

73

we really have to trespass into Buckingham Palace to make the demand for an end to British nuclear tests in Nevada titilating enough to qualify for media attention (and go in there *without* an axe*!?!*) Nothing has shock value anymore on TV. It's all been done before. There's a diminishing return, and we do not have the resources of Nestlés to dream up a new series of commercials. It has no power to make a difference because it is swept out of our minds by the whirlwind of equivalent and transitory messages of dog food, The Bill, Spitting Image...

"In today's society everything is up for grabs, everything has an economic value, from the beautiful faces we fall in love with at the movies to the fascination with serial killers. And with each aspect of society, there springs forth an opposing view which is marketed alongside the original to double the sales. The status quo can, quite easily, shout out dissent on virtually any particular aspect of itself, whilst at the same time, joyfully continuing its onslaught against life".

Look at our political activity—don't you wonder why many of us seem to flit from one issue of the day to another. The media is telling us what to get uptight about. The short span of attention, jumping from one issue to the next, is the response to someone else's definition of crisis. We come to expect instant results, the immediate resolution of TV detective drama, and when we don't get them we give up too easily, lapse into cynicism or jump onto the next bandwagon. Discarding our autonomy, we throw away spontaneity and reproduce the stale formats of past struggle. But more of the same isn't going to work second time around, because capital is ready for you. Scargill attempts the redundant set-piece confrontation of mass picketing to refight the Battle of Saltley Gates at Orgreave. And got hammered.

The point of reference of such action is outside the reason for collective organisation itself, super-imposed on it by events defined by someone else. The strength of collective self-activity lies, not in the numbers involved, but in its ability to strike at the heart of the relationships between people. Once you think in terms of recruiting, you might as well join the army (or the Socialist Workers Party). The noise of incessant meetings and demonstrations is no communication at all. Being part of a mass being spoken to by the 'alternative' leadership is so dull that political groups have to rely on theatrical (usually musical) shows to be at all attractive. The numbers game is also immediately sectarian because any group that plays must always put down other candidates for power and influence. Groups that play put forward a programme which they take very seriously, and expect the public/the working class (delete as appropriate) to take just as seriously. It is the competitive dead-end of elitist group politics.

The project of collective self-realisation puts up no candidates to vie for power, has no professional organsers, cadré, no membership and hence no rank and shuffling file. If we are going to destroy this rotten system, we will have to build a self-managed society which can counter the dominant system until such time as we are strong enough to destroy it. To achieve that we will *at the very least* have to learn how to organise ourselves, not somebody else and work for ourselves, not for somebody else.

"Maybe you haven't got any definite demands? Is that so? Yes? We'll let you in on a secret: neither do we! And quite right too: it's the BEST one... We want an end to the whole lot. You say, "this is irresponsible, you'll never win anything". You're wrong, we've already won, we've found ourselves and one another, we've communicated, we've reinvented for ourselves friendship... activity, we've laughed as rarely before. It's enormous!" Les Lascars, LEP electronics (tech college), France

a message from your organisers

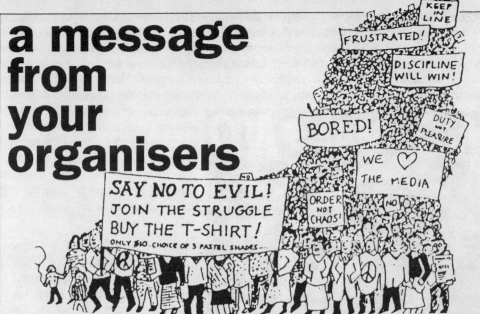

WE WELCOME EVERYONE TO TODAY'S DEMONSTRATION. We expect it to be one of the largest this country has ever seen. Let us march as one to show our government how upset we are about the state of the world.

For this demonstration to be effective we must march with dignity and unity. Comrades, a DISCIPLINED march is essential if we are to avoid losing the support of the media, the international press and the police. So please remember to follow the RULES AND REGULATIONS of the demonstration. And please OBEY all commands given by the marshals and the police, who will be working together throughout the demonstration to ensure peace and order.

At the end of the march there will be a long rally, with speeches by several very important people. After the rally, please disperse as quickly as possible and go back to your homes. Remember, DISCIPLINE is of the utmost importance. WITHOUT IT, EVERYTHING WILL COLLAPSE.

RULES AND REGULATIONS

1. In order to help you channel your anger and frustration in a constructive way, the organising sub-committee has suggested the following slogans which you may like to chant:
"Major, Major, Major, Out, Out, Out!" and "What do we want—a change of leaders. When do we want it—in due course."
NOTE ~ The following chants are NOT acceptable: "Bombs, bombs, bombs not jobs" and "Burn it down, burn it down, burn that fucker to the ground".
2. The march will be flanked on both sides by uniformed marshals. Please do NOT break the formation, and do NOT, on any account, attempt to communicate with passers-by, without prior authorisation from the publicity sub-committee.
3. Running is STRICTLY forbidden.
4. If you spot any extremists, do NOT approach them, but inform the marshals or the police, who are qualified to take the appropriate action.

Today's events are the culmination of months of planning aimed at achieving maximum boredom, as a gesture of solidarity with the people on whose behalf we are marching. With your cooperation, we can make today a massive success and start building for **a repeat performance next year**.

Nothing confuses and riles authority more than refusal to acknowledge its power and play by its rules. Marching through back streets, being photographed, rallying for this, rallying for that, impedes what we have to say, how we say it and how we *could* be organising, as a *social* movement. The whole country can march for one thing or another, at one time or another, and it don't mean shit. We are only symbolically present at demonstrations, a lonely crowd of numbers present only if the cameras and head counters turn our way. Thousands of people, together—if without a specific objective of material creation or destruction—proves only the strength of state control that allows such huge gatherings without practical consequence. Rallying every Saturday begs the question: what are we doing the rest of the week?

"Slowly you realise that you have become a spectator, an object. Your politics take place on a stage and your social relations consist of sitting in an audience or marching in a crowd. The fragmentation of your everyday experience contrasts with the spectacular unity of the mass"

Anti-Mass—

Methods of Organisation for Collectives

The media is not your friend, whether it be New Musical Express, The Independent or Channel 4—they filmed poll tax rioters, that film went to the police and some of those people are still in prison. It's stunning to find that some groups of people still pander to the media expecting to get fair treatment, then moan when they get misquoted and stereotyped.

I cannot tell you not to speak or respond to the media. I cannot tell you they will use you, marginalise you, ridicule you, or grass you up and that your existence and dreams will be reduced to a talking head and 'good copy'. This, citizen consumer, you have to find out through practice. Try it one time; participation in the media is the best way to understand its domination

And in tomorrow's news...

In this topsy-turvy world of ours, what is presented to us as news has such a short lifespan that it is becoming increasingly hard to keep up. Which is of course what those in control of the media revel in—if we can't keep up, then we can't comprehend what is really going on. Our masters' voice doesn't only have control of the information that is presented (and the limited opinions surrounding facts), it also controls the speed at which this information is rammed down our throats. The newspapers will always be limited to reporting yesterday's news whilst TV is now capable of presenting news 'as it happens'.

But what of other voices, what has up until now been called 'The Alternative Media'?

In most places non-existent, in others either monopolised by the left or hopelessly out of date. It's probably too late to start talking of the L.A. riots or even the riots over here for example, as the media have spewed out a mountain of information since. Forgetting about what has happened is commonplace—it has to be. The consumer of media must be like a canvas, with which today's news can be painted on, to be wiped clean and freshly painted on tomorrow. It's hard to cope otherwise. Things are not necessarily permanently forgotten but lose their conversation value very quickly.

RAPID RESPONSE

An idea to combat such a state of affairs and expose affairs of the state, would be to be able to respond quickly to what happens (whether is deemed newsworthy by the established media or not). Since the materials for producing free flysheets which could be handed out to people in the streets are generally beyond our means (it can also be dodgy, as the authorities get quickly aware of who's talking dirty words to the population), speedy flyposting isn't...

...Many of the more important things aren't given much media coverage, which is where we come in...

One idea that we've come up with is to have a pre-made newspaper template which can be used repeatedly. This has the advantage that if it catches people's eye, and appears again the next week with a different story, then they're more likely to continue reading. In China they have public boards where people can put things up for others to read... we have only our streets and the few areas convenient for flyposters to work with—having an image which can become familiar to people (and newspaper templates are already familiar to most, if not all, of us) is a useful tactic to grab and maintain people's interest. Advertisers use this familiariity to their benefit, for example, the 'Tell Reg' billboards.

...[Ideally, I like to avoid the media; I don't own a telly and don't read newspapers, but I keep my eyes open. I see newspaper advertising boards and I can easily walk into a newsagents and read the dailies. If I so choose, I can keep myself informed of what the media is spouting whilst retaining my distance. Friends and conversations with other folks are probably the best sources of what to write about]...

77

THE WHOLE JOB'S FUCKED

"Even if we cannot yet see the breaches in the electrically charged barbed wire, we already know that inmates found their way out of the entrails of earlier mechanical monsters, camped outside the hulks that had seemed so real, and saw the abandoned artificial carcasses collapse and decompose."
 Fredy Perlman

The media is integral to the maintenance of hierarchical social control. The external models of experts have supplanted our own lived experience. With social life mediated by a bureaucracy of image technicians, communal life has been disrupted and denied; a surrogate, supervised community is the replacement. Under these conditions, a small elite makes the rest of the people dependent upon its tutelege for survival.

We have never been so comprehensively administered. We have also never been so involved in the organisation of our own exploitation. Most importantly, the system has never been so *dependent on our participation*. Though it continually convulses, stumbles and contradicts itself, the media machine (and the system it keeps buoyant) will not of itself collapse. **It must be made to collapse**. The simple refusal of dominant culture (alongside the growing refusal of work, tax evasion) can threaten supervised consumption precisely through its autonomous, spontaneous and hence uncontrollable aspect—the refusal to take part, the refused myth of political economy and hierarchy. Even though we may, on occasion, be offered the publicity for our actions (by the 'sympathetic' lefty journalist), we waste everyone's time playing to the cameras. We waste *our own* time studying the screen to find our reflection. Here are only the shadows of how we live and could be living. Throw your telly out the window (open the window first) and when you next move to take action that reclaims (however temporary) autonomous control of space—street, land, factory, mental environment/ 'cyberspace'—remember: we live in one the few remaining countries where the media are not attacked as soon as they try to film or photograph our manifestations.

Then ask ourselves: to what degree do our behaviour, our relationships, even our counter-information, emulate the practice of the media? It is to the way in which we can come together to transcend the environment of the technology of isolation that we must apply our efforts and attention. How we organise to this end is organic; it will be neither formal nor permanent, and it cannot be programmed or platformed. We start by communicating on equal terms—without the mediation of technology, specialism and representation—with those who suffer the same alienated experience. We grow stronger as like-minded people work together seriously (and playfully) in common projects of self-determination that shatter established social relations. The 'heart of the State' is found and demolished in our own relations. Let your *desire* be armed. Through the collective action of destruction of the institutions of social misery, we will become subjects, agents of change.

"The most pertinent revolutionary experiments in culture have sought to break the spectators' psychological identification with the hero so as to draw them into activity by provoking their capacities to revolutionise their own life. The situation is thus made to be lived by its constructors. The role played by a passive or merely bit-part playing 'public' must constantly diminish, while that played by those who cannot be called actors but rather, in a new sense of the term, 'livers', must steadily increase."

Liberation begins when we no longer want or need someone to tell us what kind of day it was

Groups involved in radical alternatives to centralised media

Anti-copyright — runs flyposter distribution centres, contents of which is distributed at cost of copying. Also organises irregular networking congresses. Write to Box Cat, 52 Call Lane, Leeds, W. Yorks, LS1 6DT for details of a group near you. If there isn't one, they'll help you set one up.

Fast Breeder — "Technology must be opened, with a crowbar if necessary, to other influences". An E-mail Bulletin Board Service is up and running and can be got via modem on 071 820 8339. For more information/activity on the subversive potential of misused technology you can also write to them c/o BM Jed, London WC1N 3XX.

The Lancaster Bomber — c/o GA Mail Order, 151 London Road, Camberley, Surrey. Green anarchist magazine, full of media hatred. Recommended.

ByPass — A new magazine for 1994 to promote *direct* sale, exchange and communication between pamphleteers, zinesters and propagandists. A UK based, Factsheet Five-style, review and listing service. Send them a copy of what you're doing and get a copy of the issue in which it appears FREE c/o 21 Cave St, Oxford.

Oxfin shop — 21 Cave St, Oxford. Formerly the Oxford chapter of the Free Information Network. Supports all autonomous media. Typesetting and design, cheap in-house copying, bulk pamphlet making facility. Outside agitators welcome. Fax: 0865 790673.

This book was produced in Pagemaker 4 on an IBM compatible computer. The text is 10 point Times New Roman and 9 point Switzerland Condensed, printed out at 600 dpi and assembled with a photocopier and a light box at Oxfin. Offset printing and binding is by BPCC Wheatons, Exeter.

Test Card F is part of a continuing body of propaganda from the Institute of Social Disengineering at Oxfin.

Also available:

TV Times—A Seven Day Guide To Killing Your TV
A5 32 page pamphlet, £1+ SAE ($3 post paid) from 21 Cave St, Oxford.

Smashing The Image Factory—A Manual for Billboard Subversion and Destruction
A5 16 page pamphlet, £1+ SAE ($2 post paid) from the same address.

Many thanks to: Julia, Rich, Matt, Mandie, the Lancaster Bomber, Harry, Graham, Paul, Todd, Mike, armchair, Ade, Jame, Sam, Ed.

People whose grafix have been ripped off: R. Crumb, Mouly (Raw), Duane Elgin, J.F. Batellier, Lowry, Ralph Johnson, Kathy Tate, Seth Tobocman].

PRESS

AK Press publishes, distributes to the trade, and retails mail order a wide variety of radical literature. For our latest catalogue featuring several thousand titles, please send a large self-addressed, stamped envelope to:

AK Press
22 Lutton Place
Edinburgh, Scotland
EH8 9PE

AK Press
P.O. Box 40682
San Francisco, CA
94140-0682

Some Recent Titles from AK Press

Chronicles of Dissent — Noam Chomsky, introduction by Alexander Cockburn

ISBN 1 873176 85 6; 400pp two colour cover perfect bound 5 x 7⅝; £10.95 / $16.95.

Interviews with David Barsamian 1986-1991. An accessible overview of Chomsky's political thought.

Some Recent Attacks: Essays Cultural and Political — **James Kelman**

ISBN 1 873176 80 5; 96pp two colour cover perfect bound 5½ x 8½; £4.50 / $8.00.

In this collection, Kelman directs his linguistic craftsmanship and scathing humour at targets ranging from 'private profit and public loss' to 'the endemic racism, class bias and general elitism at the English end of the Anglo-American literary tradition'.

"Hmm! That was a funny ending!"

Sabotage in the American Workplace — edited by **Martin Sprouse,** illustrated by **TracyCox**

ISBN 1 873176 65 1; ISBN 0 9627091 31 (U.S); 250pp full colour cover, perfect bound 8½ x 11; £10.95 / $12.00.

Sabotage in the American Workplace is as common as work itself; these stories present the other side.